LEGENDARY L

— OF —

THE MENDONOMA COAST

CALIFORNIA

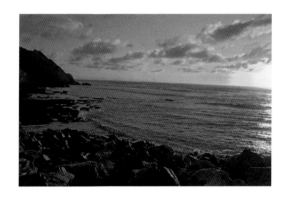

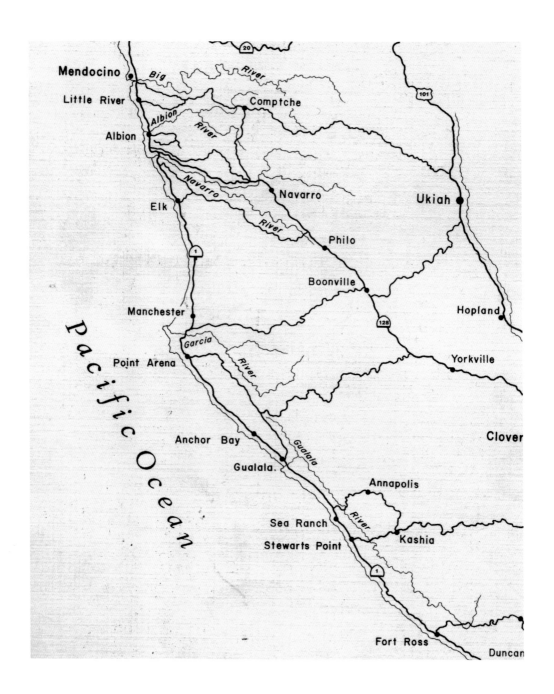

Page 1: Sunset at the Point Arena Pier
Even after many years, the Point Arena Pier remains a central gathering spot for the southern Mendocino coast--whether it is surfing, having dinner at the nearby Pier and Chowder House, or simply enjoying the view of the ocean at sunset. (Author's collection.)

Page 2: Mendonoma Map
This map details the Mendonoma area. (Author's collection.)

LEGENDARY LOCALS

OF

THE MENDONOMA COAST

CALIFORNIA

TAMMY DURSTON

LEGENDARY
LOCALS

Copyright © 2012 by Tammy Durston
ISBN 978-1-4671-0013-7

Published by Legendary Locals, an imprint of Arcadia Publishing
Charleston, South Carolina

Printed in the United States of America

Library of Congress Control Number: 2011945288

For all general information, please contact Arcadia Publishing:
Telephone 843-853-2070
Fax 843-853-0044
E-mail sales@arcadiapublishing.com
For customer service and orders:
Toll-Free 1-888-313-2665

Visit us on the Internet at www.arcadiapublishing.com

Dedication

To my unsung heroes: my brother, David, who watched over me; my father, Vernon Durston, a model of unconditional love; Jim & Sharon Lieberman, who took me in; Bill and Cathi Matthews, who changed my life; Helena Bowman, who encouraged me; Lucie Marshall, who believed in me; Genie Lester, who encouraged me to write; Brad Smith, who was an inspiration; Nana, who inspired all of this with her interesting life; David, who opened his heart and my wonderful children, Max, Alex and Chloe who I love.

On the Cover: From left to right:
(TOP ROW) From left to right: (top row) Ancilla Curti Scaramella, immigrant (Courtesy of Cheri Carlstedt; see page 48), Jean Piper, ranch matriarch (Courtesy of the *Independent Coast Observer* (ICO); see page 100), Jay Baker, local businessman (Courtesy of the Baker family; see page 96), *Sea Foam*, the wreck of the legendary schooner (Courtesy of Cheri Carlstedt and Steve Oliff; see page 89).
(MIDDLE ROW) Original Point Arena Lighthouse (Courtesy of the Point Arena Lighthouse Keepers Association; see page 4), Betty O'Neil and Kathy Rubel Dimaio, founders of Gualala Arts (Courtesy of the ICO; see page 79), Niels Iversen, industrialist (Courtesy of Cheri Carlstedt and Steve Oliff; see page 28), H.A. Richardson, rags to riches businessman/landowner (Courtesy of William Richardson; see page 20), Ralph McMillen, local businessman (Courtesy of Cheri Carlstedt and Steve Oliff; see page 57).
(BOTTOM ROW) Essie Parrish, Pomo spiritual leader (Courtesy of the Sonoma County Library; see page 10), the Point Arena Ladies Band (Courtesy of Cheri Carlstedt and Steve Oliff; see page 91), Emmett Gillmore, the Gillmore Brothers storekeepers (Courtesy of Cheri Carlstedt and Steve Oliff; see page 43), Joanna MacLaughlan, newspaper founder and publisher (Courtesy of the ICO; see page 72).

CONTENTS

ACKNOWLEDGMENTS

This book could not have been written without the assistance of Cheri Carlstedt, whose assistance and general good humor were invaluable. She was truly "my right arm." Steve Oliff and Steve MacLaughlan of the ICO were extremely helpful as were Dorothy and Gary Craig, Kathy Rubel Dimaio, Bill Richardson, Arline Hamilton Chambers, Bill Kramer, and Joyce Hamilton Pratt. A special thanks goes to Ralph, Esther and Lori Bean for their assistance. I would also like to thank Bruce Anderson, Mark Scaramella, the Mendocino County Historical Society, the Kelley Museum, the Sonoma County Library, the Fort Ross Interpretive Association, the Point Arena Lighthouse Keepers Association, and the Annapolis Historical Society.

INTRODUCTION

Historian and novelist Wallace Stegner wrote that "Local history is the best history, the history with more of ourselves in it than other kinds. It is the record of human living in its daily complexity, and the sense of place is strong in it. Its actors are our neighbors, our families, human lives on their slow way into memory and tradition."

Where is Mendonoma? One hundred miles north of the city of San Francisco there exists a stretch of land called the Sonoma Mendocino coastline. A throwback to thoroughfares of the past, the local highway is a two-lane road that carves its way through rocky cliffs above deserted beaches. The world's tallest tree—the coast redwood—is native here. Although almost all of the original redwoods are now gone from the coast, it is almost as if they are still here as the remnants of their past lives line the coast roads.

Poet John Masefield wrote regarding the coast redwoods: "They are not like trees, they are like spirits. The glens in which they grow are not like places, they are like haunts—haunts of the centaurs or of the gods. The trees rise up with dignity, power and majesty, as though they have been there forever."

These trees are what first drew European settlers to the area. Drawn to California for gold, they quickly learned there was money in the timber.

The Pomo, the first people to live in the area, measured time according to the seasons and knew the relationship between the land and the people. During the summer, the Pomo lived by the sea and gathered food. In the late fall, they moved back inland to villages on the ridge. In 1812, Russians established a settlement at Fort Ross. Then came more settlers from other faraway areas—many settlers from the East Coast in search of gold and timber. Other people came for a new life. In later years, people moved to the coast to change their lifestyle, be more in touch with nature, or escape the cities. Each of these groups of people has a story to tell.

Early residents of the area focused on survival. The Pomo tried to continue their lifestyle as the new settlers invaded. Sometimes they were successful and sometimes not. Modern Pomo have made efforts to sustain their culture and their efforts should be acknowledged. Settlers from the East Coast and other countries foraged a way of living—sometimes from the land—and their brave struggles are inspiring too. Modern-day settlers brought their own talents to the area in the form of community involvement and new vision.

The Gualala River has served as the border of Sonoma County (to the south) and Mendocino County (to the north), but many people call the area "Mendonoma," blending the two names. Each town in the 50-mile stretch from Fort Ross to Manchester has its own unique flavor.

Many books have been written about the beauty of the Sonoma Mendocino coastline. Few books, however detail the rich wealth of interesting people who have inhabited the area. From Native Americans to modern-day architects, Mendonoma has been home to many different visionaries, heroes, and legends.

There are many tales of people doing things to help others. Enterprising pioneers built bridges, created fire departments and rescue services, and built schools. Fifty years ago, dedicated volunteers created Gualala Arts, whose mission is to promote public interest and participation in the arts. Volunteers also created the Gualala Community Center. The Fort Ross Interpretive Center was created to preserve the history of Fort Ross. Residents in Annapolis bound together to save the historic schoolhouse, and residents in The Sea Ranch did the same for the Del Mar schoolhouse. Point Arena

restored its theater and lighthouse. Lacking nearby medical facilities, coast residents also organized to obtain medical offices to serve the coast, and Redwood Coast Medical Services was born. Volunteer fire departments were created. Newspapers were published, businesses were born. Individuals also did their part. Some saved lives from shipwrecks or used their skills at medicine. Concerned that the stories of the past would be forgotten, some people gathered historical information to share. Teachers worked diligently to ensure students stayed up to date. Entrepreneurs inspired others to try new things. All of these people had a common goal of fostering the volunteer spirit.

The *San Francisco Call* newspaper reported in 1896, "All heroes are pretty much made of the same thing and modesty is one of them." Heroes on the Mendonoma coast are no different.

This book contains the stories of many of the unsung heroes, legendary locals, and colorful personalities of the area. Some of the unsung heroes include early pioneer J.C. Halliday, who worked to build the first high school on the coast, and Joanna MacLaughlan, who established the *Independent Coast Observer*, the coast's weekly newspaper. Betty O'Neil and Kathy Rubel Dimaio first thought of having an art show in the area. Their ideas turned into Gualala Arts and Art in the Redwoods, a yearly show attended by hundreds of people. Pomo activists such as the Parrish family worked on maintaining their culture.

Local legends such as the schooner the *Sea Foam*, which was one of the only methods of transportation and shipping available to coast residents and sadly wrecked in 1931, as well as logging legends such as Lester Giacomini and Ralph Bean, are profiled. Jean Crispin Piper, the matriarch of the Piper Ranch who raised sheep, hunted, and drove a jeep, is detailed. Steve Oliff and Cheri Carlstedt spent hundreds of hours gathering memories, stories, and historical photographs from residents and wrote a detailed history book. Jay Baker and John Bower were legendary businessmen who were determined to get ahead.

In addition to unsung heroes and local legends, many other personalities call the Mendonoma coast their home. Visionaries such as the original The Sea Ranch design team, including Al Boeke, landscape designer Lawrence Halprin, Charles Moore, Donlyn Lyndon, William Turnbull, and Richard Whitaker, along with builder Matt Sylvia, changed the landscape of the Del Mar Ranch forever. They focused on building homes that would preserve the natural environment and not impact the land. Lawrence Kroll and his family created a new lifestyle in a communal living environment with organic gardens and a summer camp for kids. Creative visionaries also include Jimmy Hodder, drummer with Steely Dan, Rosemary Campiformio, who created St. Orres Inn, and Fionna Perkins, poet laureate. Together all these people from the past and present have made the Mendonoma coast a unique place to live or visit.

CHAPTER ONE

Adventurers, Heroes, and Pioneers

The people in this chapter remembered Helen Keller's words: "No pessimist ever discovered the secret of the stars, or sailed to an uncharted land, or opened a new doorway for the human spirit." Whether they travelled from a land far away or from their backyard, these Legendary Locals opened a new doorway in one way or another. To be adventurous could mean risking everything to try something new, or it could simply mean coming to another country to start a new life. From early pioneers to modern-day visionaries and heroes, the people of northern Sonoma County and the Mendocino County coastline constitute a spirited bunch.

The first settlers, the Pomo, were acutely aware of the gifts of the area—the picturesque coastline, the almost constant fog that encouraged the growth of the redwoods, the milder inland climate that offered excellent growing conditions—and appreciated the land where they lived. In later years, several Pomo elders worked hard to preserve their traditions and natural resources. Early pioneers had to risk harsh weather, rugged terrain, and limited resources to survive. It took a full day to travel to Point Arena on the coast road from southern Sonoma County and a traveler had to open and close 17 separate gates! Roads were not well developed until the 20th century. Travelling by ocean was treacherous and also time consuming. Pioneers risked everything to create new businesses and towns, and many succeeded. Residents like H.A. Richardson arrived in the area with nothing and became successful businessmen and landowners. Later, historians and other preservationists worked hard to document and record their actions. Other visionaries include those who wanted to highlight the unique beauty of the Sonoma Mendocino coastline, such as The Sea Ranch architects and the founders of Oz. Heroes range from those who saved lives, created new community organizations, and fostered education and learning to those who helped others simply by being good citizens and neighbors.

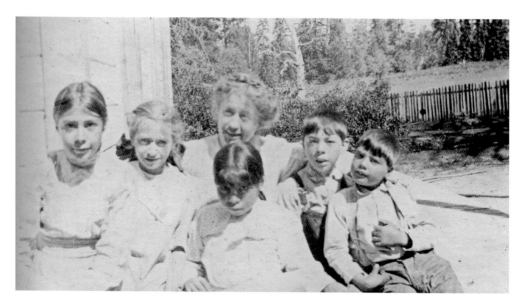

Essie Parrish

The Kashaya Pomo (whose name means "The People from the Top of the Land") first inhabited the land from a few miles south of the Russian River north to the Gualala River in Gualala. Approximately 1,500 people lived in villages in the area. Perhaps the best-known Sonoma County Pomo was Essie Parrish. Essie Pinola was six years old when her people, the Kashaya Pomo who reside near Stewarts Point in northwestern Sonoma County, acknowledged her as their "dreamer." The term can best be translated to mean "visionary," but also includes "doctor" or "healer," as well as "priest" and "prophet." As a child, Essie attended the Dirigo School, a small school that no longer exists. Pictured here with Essie's teacher, Anna Marx Martin, are (left to right) Bessie Haupt, Mabel Nobles, Essie, Albert Haupt, and unknown. (Courtesy of William Richardson.)

Spiritual Leader

Parrish raised 13 children, managed an apple cannery, was an accomplished basket weaver, and, for 70 years, provided spiritual focus for her people. She was the religious, political, and cultural leader of her tribe. Her Indian name was Pewoya, and she was born, in her own words, "on the rancheria in an old shack between the redwood trees and the acorn trees." Her birthplace was on Charlie Haupt's ranch on a wooded ridge north of Fort Ross, seven miles inland from the sea. Haupt's wife was Pomo and it was through her intervention that the Kashaya, who worked as farm laborers, made their home on his ranch. The Pomos lived there until 1920, when the federal government bought the 42-acre Nobles Ranch, five miles west on Skaggs Springs Road, and established the Kashaya Reservation. With her friend Mabel McKay, she wove baskets at the Sonoma County Fair each year, patiently answering the questions of a curious public. Parrish is shown to the right with Mabel McKay on the left. (Courtesy of Sonoma County Library.)

Mission to Educate Children

Throughout her life, Parrish used her powers to unify her people. She was the acknowledged center of the community, recognized as the last of four promised leaders sent by the spirits to guide the Kashaya Pomo. After marrying Sidney Parrish, a Point Arena Pomo, she lived in Graton and Windsor, but always considered the Kashaya Reservation her home. It became her mission to educate the Kashaya children in the Indian language, culture, and laws. She not only taught in the reservation school, but compiled a Kashaya Pomo dictionary, working with Robert Oswalt, a Berkeley scholar well known in the field of Indian linguistics.

Her spiritual gifts, particularly the ability to prophesy and interpret dreams, drew scholars to her. Parrish was "discovered" by the most noted anthropologists of the time, including the University of California's Alfred Kroeber and Samuel Barrett. She was a sophisticated observer of her society. As a subject for social scientists, Parrish made more than 20 films, including a documentary on her life that won a Cannes Film Festival award in 1969.

She was always in demand as a speaker, talking of her dream visions and the history of her people. She understood her power, but in her own terms. In 1972, in a talk to the American Language Association, she told the scholars, pointing to her head, "That's what I have within me. I see it and I know it and I know it is true."

During World War II, the reservation emptied as families moved into the valleys to find work in the orchards and hop fields. Essie and Sidney Parrish and their family moved to Sebastopol to the Barlow apple ranch, returning to Kashaya each weekend, as gas rationing allowed.

After the war, Parrish broke precedent by opening the tribe's ceremonial roundhouse to outsiders for the annual White Deer Dance and Strawberry Festival, bringing hundreds of visitors to the reservation. She was there to greet the reservation's most important visitor, Robert Kennedy, when he came in 1968 on a fact-finding trip investigating conditions in Indian schools. Essie escorted him to the roundhouse and made him a gift of one of her treasured baskets. The regal manner in which she met him, observers said, was "like a head of state."

She was a familiar figure in Sonoma County in her lifetime. She took a lead role in persuading the federal government to grant a portion of the former CIA "listening post" near Forestville for an Indian education center, known as Ya Ka Ama, which means "our land" in Kashaya. Parrish is buried at the Kashaya reservation—where the ceremonial roundhouse was locked upon her death, to be reopened when another "dreamer" comes to take her place. (Courtesy of Sonoma County Library.)

The Original Point Arena Lighthouse
One of the most recognizable landmarks on the Mendocino County coast is the Point Arena lighthouse. Without a lighthouse, shipwrecks were common along the Mendocino coastline during the 1800s. As shipping increased, it became apparent that a lighthouse was needed and construction of the Point Arena lighthouse began in 1869. The first lantern was lit in 1870. When the tower was built, it was 22 feet in diameter and the base wall was six feet thick and 100 feet high. The original keepers' dwelling was a large white building to the rear of the lighthouse, housing four keepers and their families. (Courtesy of Point Arena Lighthouse Keepers Association.)

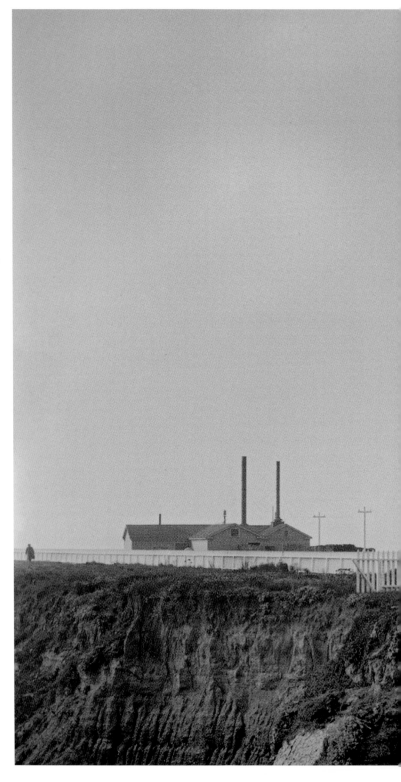

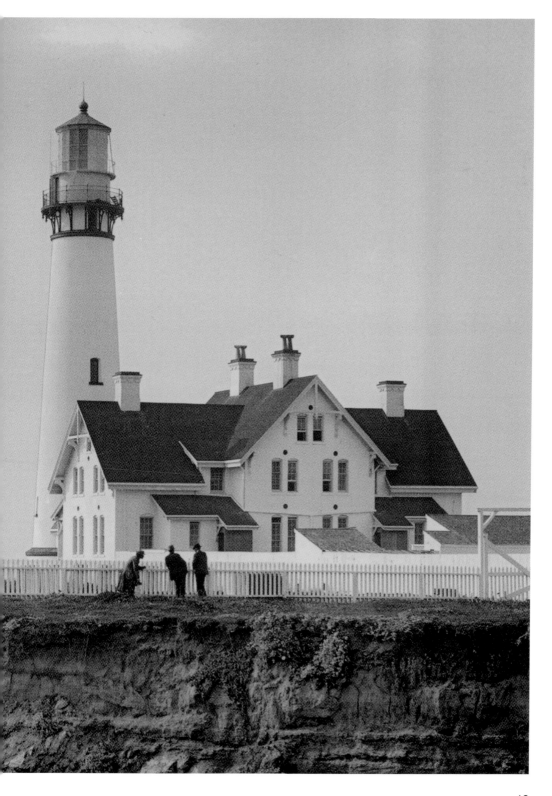

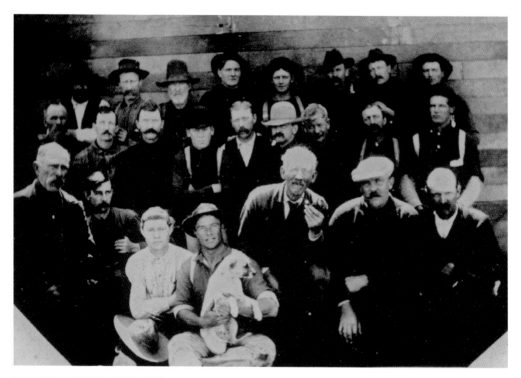

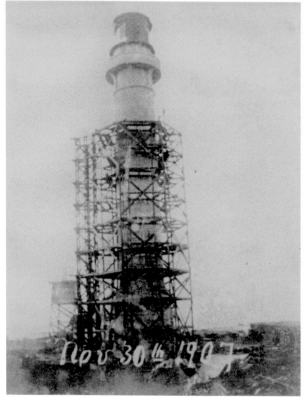

The Crew That Rebuilt the Lighthouse
In the 1906 San Francisco earthquake, the lighthouse was damaged beyond repair. The lenses were shattered, and the brick tower and keepers' quarters were condemned. George Hooke, Lighthouse Service engineer, was in charge of the repair. (Courtesy of Cheri Carlstedt and Steve Oliff.)

The Lighthouse in 1907
An entirely new lighthouse had to be built, including a new Fresnel lens. The crew finally finished their project in September 1908. (Courtesy of Cheri Carlstedt and Steve Oliff.)

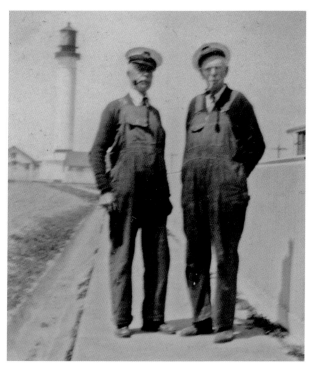

Point Arena Lighthouse Keepers
Before electricity, the lens of
the lighthouse had to be rotated
by a hand crank connected to a
160-pound weight. The keepers were
called "wickies" and had to refuel the
hydraulic oil lamp every four hours.
The keepers often had to contend
with gale force winds and heavy fog.
For the keepers and their families,
the Lighthouse Service decided to
build four separate houses. This
allowed the keepers, who worked
many shifts, to be with their families.
(Courtesy of Joyce Hamilton Pratt.)

A Solitary Job
Keepers had to work in a great
degree of solitude. Someone was
always on duty. The Hamilton
children detail stories from their
father regarding how the keeper
had to clean the lens by climbing
outside it and being lowered inside a
bucket. Pictured is Lovel J. Hamilton,
assistant keeper, with his children,
Harry and Joyce in the early 1920s.
(Courtesy of William Kramer.)

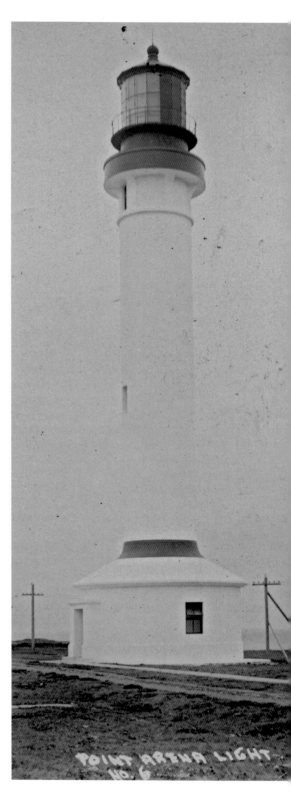

Children of the Keepers
Top photograph: Joyce Pratt and William
Kramer at the Point Arena Lighthouse keepers'
quarters. Rather than resenting the isolation, the
children enjoyed the idea of living in the foggy
area and sometimes used a ladder to climb down
to the beach. In 1977, an automated aircraft style
beacon was installed and the Fresnel lens was
discontinued. The next year, the fog signal at the
lighthouse was suspended. (Courtesy of William
Kramer.)

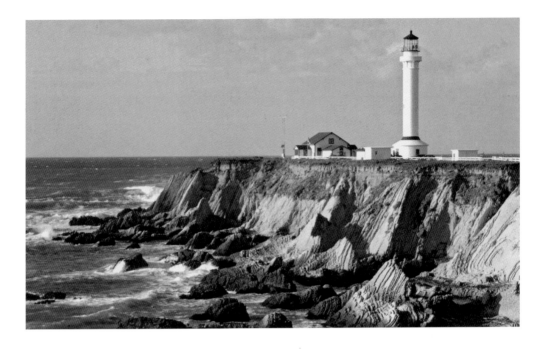

Point Arena Lighthouse Keepers Association

In 1984, the nonprofit group Point Arena Lighthouse Keepers acquired the lighthouse, and then in 2000 they became owners of the property. The Point Arena lighthouse is the only West Coast lighthouse of significant height that you can climb to the top. However, in the years after it was rebuilt in 1908, the lighthouse had been affected by the adverse weather conditions and deferred maintenance. Chunks of concrete were falling from the tower to the parking lot, the tower's gallery had to close due to public safety, and the Fog Signal building was in dire need of repair. (Courtesy of the Point Arena Lighthouse Keepers Association.)

Lighthouse Restoration Volunteers

In 2006, the lighthouse directors, under the direction of President Luciano Zamboni, started the restoration process. The California Cultural and Historical Endowment was a major funder of the restoration. The board of directors of the keepers association began the "Save the Light" fundraising drive and raised thousands of dollars with the help of many community members. The project managers were Pauline Zamboni, Nik Epanchion, and lighthouse director Rae Radtkey. This project is an example of how a determined group of community-minded people can make a huge impact. Many dedicated volunteers have helped with the lighthouse restoration including Dorothy Halliday, Bob and Grace Carter and Linda Bell. (Courtesy of the Point Arena Lighthouse Keepers.)

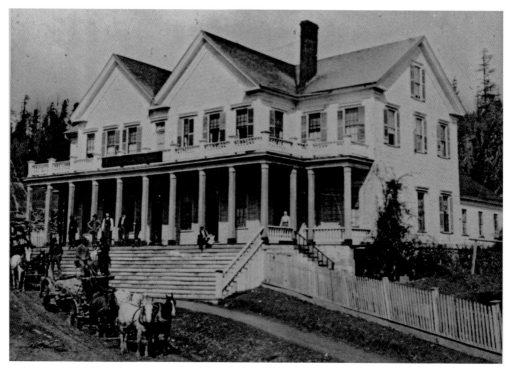

Cyrus D. Robinson

The first white settler in the Gualala area was John Northrope in 1857. Robinson purchased Northrope's land in 1858 and settled in Gualala shortly thereafter. He immediately started a hotel business. Born in Erie, Pennsylvania, in 1823, Robinson moved to Chicago in 1844 and became a grocery clerk. In 1847, he opened his own store. Then, in 1849, he purchased a team of oxen and came to California. After various travels, he and his family settled in the Russian River area where he maintained a ferry and hotel. He then moved to the Gualala area. In 1862, the Gualala Milling Company began operations near the hotel. Robinson, known to everyone as C.D., supervised the post office, the Wells Fargo express, and the Western Union telegraph operations. He built Gualala House in 1872. It burned, and then he rebuilt the Gualala Hotel in 1903. This photograph, taken before 1903, shows Cyrus in a coat on the porch. His son, Frank, is seated on the porch steps holding Frank's daughter Edith. Edith's mother is to the right. Edith's Uncle Ed is on the wagon with the horses. In an interview with Edith Robinson Penry in the book *Mendocino County Remembered*, she says that her Uncle Ed hauled all of the timber for the new hotel with those four horses. She also said "there were many tramps in those days. They were allowed to eat in the hotel kitchen and they slept in the hay at the livery stable. . . ." She also remembered the fire: "My mother went upstairs one night about nine o'clock to go to bed. The whole roof of the hotel was on fire. She rushed downstairs and knocked at the bar room door (ladies never went in bars)…A man carried me downstairs in my nightgown out in the middle of the road and stood me in a cow pile. I thought I was disgraced and I don't remember anything else about the fire." (Courtesy of Dorothy Craig.)

The Gualala Hotel in 1980 (ABOVE RIGHT)

After the original Gualala House burned, Cyrus Robinson rebuilt his hotel in 1903 and renamed it the Gualala Hotel. According to Edith Robinson Penry, the new hotel was built nearer the town so C.D. Robinson, her grandfather, could get down to the boat landing steps. Her grandfather was an enthusiastic fisherman up to a few days before his death. In this 1980 photograph showing many Gualala residents, the hotel looks much as it does today. (Courtesy of David Torres.)

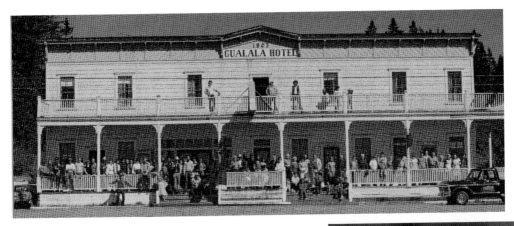

Joseph Crocket "J.C." Halliday (RIGHT)
Few coastal settlers are credited with as many business and
civic ventures as Halliday. Born in 1854 in Nova Scotia, he
came to California in 1874 as a blacksmith apprentice and then
in 1875 came to Point Arena and bought the Hugh Graves
blacksmith shop. He owned the stage that traveled from
Mendocino to Cazadero (90 miles). At the time, it was the
longest stage system in the state and allowed people from
San Francisco to travel to the coast via the railroad. Halliday
then started purchasing ranches for dairying. (Courtesy of the
History of Mendocino County.)

Halliday and Howe Livery Stable
J.C. Halliday built a sawmill on the Garcia River, and had a
livery business and garage in Point Arena. He is also credited
with building Point Arena High School in 1908 as well as
assisting with the building of many roads and bridges in the
area. He was also the president of the bank. He and his wife,
Kate, had 10 children. Halliday passed away in 1924. (Courtesy
of Cheri Carlstedt and Steve Oliff.)

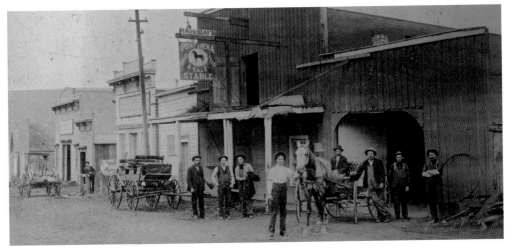

Herbert A. "H.A." Richardson (ABOVE) Richardson, called the "Tie King of the Coast," was born in New Hampshire in 1852 and came to Stewarts Point to work with timber in 1876. He stemmed from a long line of Richardsons on the East Coast who were mariners, most notably Captain Josiah Richardson, Commander of the ships *Staffordshire* and the *Stag Hound.* In 1852, Captain Richardson sailed from Boston to San Francisco in 103 days. H.A., as he was called, spent more than 50 years of his life at Stewarts Point and ended up owning 10 steamships and sailing vessels as well as extensive land holdings, including several Stewarts Point businesses, such as the Stewarts Point Store. (Courtesy of William Richardson.)

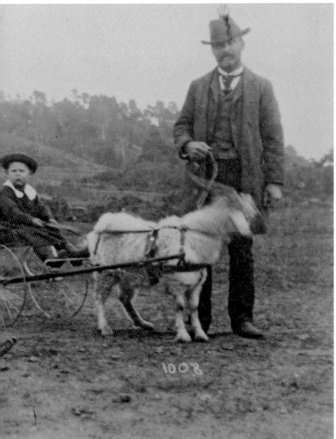

Early Stewarts Point (ABOVE)
H.A. Richardson developed Stewarts
Point into a bustling hotel, bar, and
store. Left to right are Bill Meyer,
Grace Richardson Butterfield,
Donald R. Richardson, Fred Fisher,
Archer Richardson driving, and
Mrs. H.A. Richardson on the porch.
(Courtesy of William Richardson.)

The Richardson Family
H.A. Richardson married Althea
and had three children. In this
photograph, dated 1889, H.A. is
standing to the right. His children,
from left to right, are Archer, Grace,
and Fontaine. Pictured also is his
nephew, Andrew, son of Webster
Richardson (H.A.'s brother).
(Courtesy of William Richardson.)

21

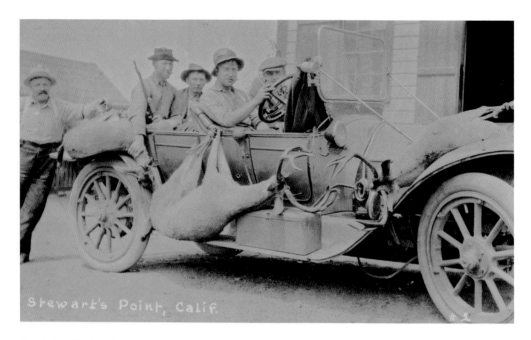

Fontaine Richardson
Font Richardson continued in the tradition of his father and operated the Richardson store after H.A. retired in the 1930s. Font and his father were largely responsible for much of the early road and highway development. Pictured are (left to right) Bill Casey, Font Richardson, Henry Lindstrom, Arch Richardson, and Homer Marx. (Courtesy of William Richardson.)

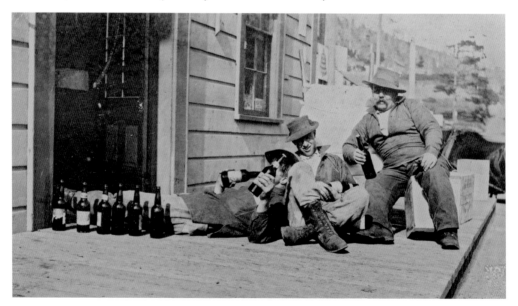

A Popular Place
Stewarts Point grew to be a popular place among the local residents for many years. From gathering supplies for the home or car to indulging in some recreational spirits, Stewarts Point was the place to go. Shown here John Prest and Charlie Dahlquist. (Courtesy of William Richardson.)

Stewarts Point Store Restoration Charles Richardson, great-grandson of H.A. Richardson, recently completed the complete restoration of the Stewarts Point Store. After extensive renovation, the store has reopened. The second floor now features dinner on Friday nights in the tradition of the old dance house. (Author's collection.)

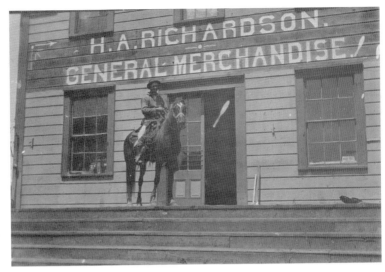

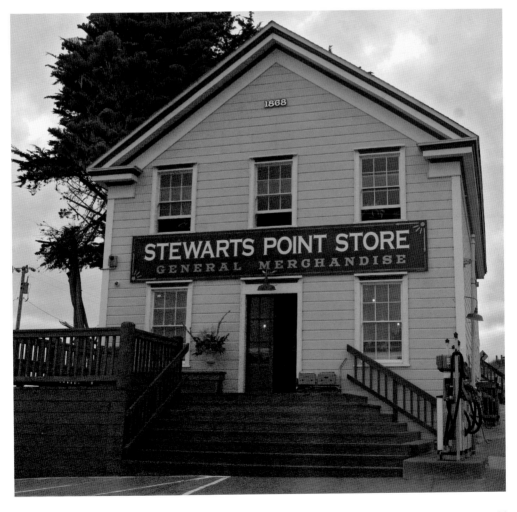

23

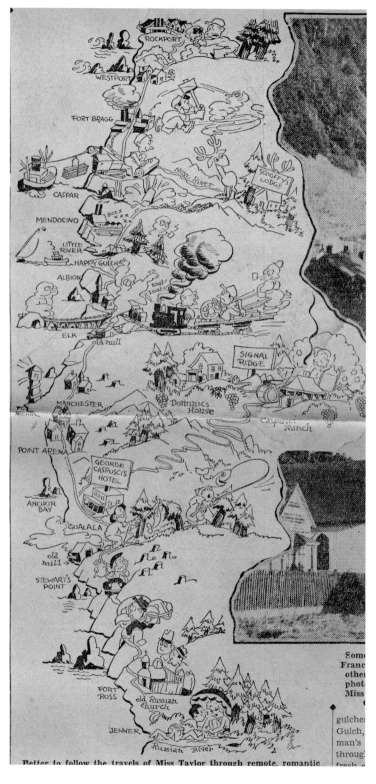

Historic Tourist Map of the Coast
In 1937, the newspaper the *San Francisco News* published a series of four articles on the Sonoma Mendocino coast. This is the map that accompanied the articles. It details some of the landmarks of the coast, many that are detailed in this book. (Courtesy of Kathy Rubel Dimaio.)

Some
Franc
other
phot
Miss

gulche
Gulch,
man's
throug
fresh

Better to follow the travels of Miss Taylor through remote, romantic

Gualala in the Early 1900s

Gualala was quite a different town in the early 1900s than it is today. Until the mid-century, it was primarily a logging town, and only in the latter years of the 20th century did it become a tourist attraction. This photograph, taken around the turn of the century, shows how the highway through town was more inland. Seen also is the Gualala Church, which no longer exists. Gualala was described as a "rough timber town" in *History of Mendocino County*, dominated by men trying to earn a living. (Courtesy of Cheri Carlstedt and Steve Oliff.)

Kathy Rubel Dimaio

As the community of Gualala grew, by the 1950s the townspeople realized they needed a more centralized building to help those in need. The Gualala Community Center Building was built in 1955 in response to that need. This 1956 photograph shows one of the founders of the Gualala Community Center, Kathy Rubel Dimaio (left), and Julia Hubbard on the right. (Courtesy of Kathy Rubel Dimaio.)

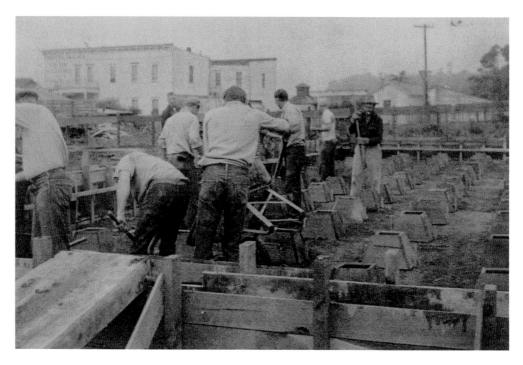

Building the Gualala Community Center
Residents from all over gathered together to build the community center. Kathy Rubel Dimaio remembers that the women would make lunch for the workers every day. The building was designed to offer support services for seniors and residents of need. (Courtesy of Kathy Rubel Dimaio.)

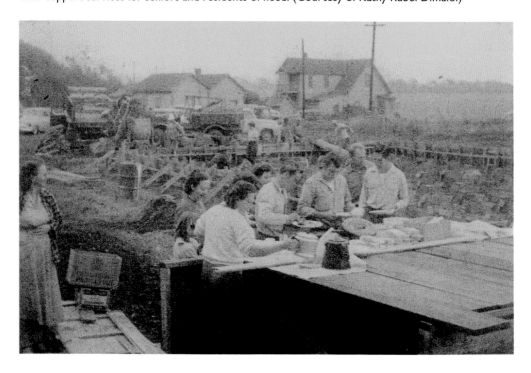

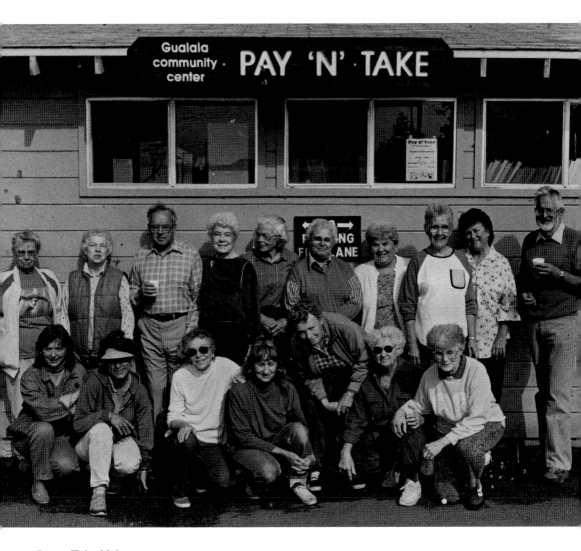

Pay-n-Take Volunteers

Community services are even more vital in rural areas. The Gualala Community Center serves the community in many ways. From providing clothes and supplies to needy families, to administering immunizations and serving meals to seniors, the community center aims to help all residents. On the first and third Saturdays of the month, residents rise early and head to the Gualala Community Center to be the first in line at Pay-n-Take, the community tag sale that gives back to the community. This photograph shows many of the dedicated volunteers who have worked at Pay-n-Take. Pictured are left to right (back row) Kate Snelling, unknown, Howard Snelling, Doris Spurlock, Elaine Legget, unknown, unknown, unknown, Pat Adshade, Walt Ratcliffe; (front row) Cathi (last name unknown), Hulde (last name unknown), Helen (last name unknown), Millie Harris, unknown, Irene Lucas, Betty Coleman. (Courtesy of the Gualala Community Center.)

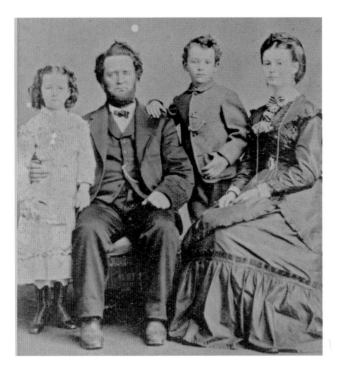

Capt. Niels Iversen
Known for being one of the coast's most industrious businessmen, Iversen first came to San Francisco in 1830 from Denmark. He settled in Point Arena in 1865 and opened a store. This store expanded into a meat market. Later Iversen opened the Point Arena Hotel. He also owned a paper mill and sawmill. In 1878, he was appointed Mendocino County supervisor and also was school trustee. Iversen donated to the City of Point Arena land that became Lake Street, School Street, and part of Port Road. (Courtesy of Cheri Carlstedt and Steve Oliff.)

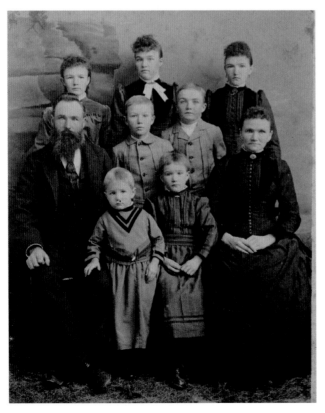

Soren Iversen
Brother to Niels, Soren also moved to Point Arena. His home on Iversen Lane is still standing. His great-granddaughter, Cheri Iversen Carlstedt, lives in the home that was built in 1870. Pictured are (back row) Johanna, Christina, and Maggie; (middle row) Soren, Arthur, Christian Garfield, and Ane; (front row) Emma and Abolena. (Courtesy of Cheri Carlstedt and Steve Oliff.)

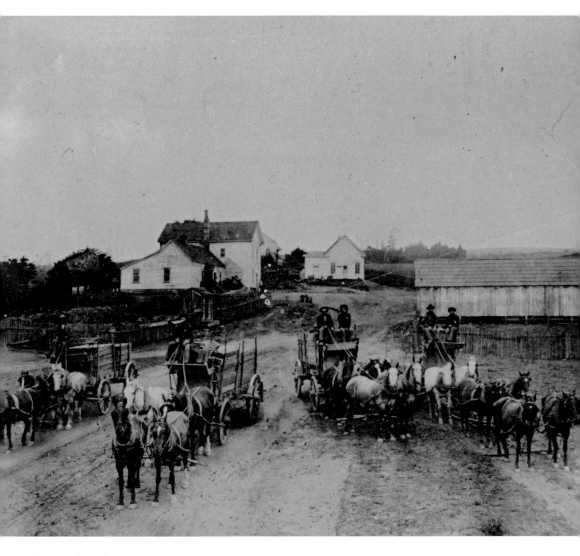

Iversen Landing
The very small town of Iversen Landing, named for Niels Iversen, consisted a chute for loading schooners, a hotel, a post office, and a small school. It was located just south of Point Arena. High Craig worked at the blacksmith shop, one of the last remaining buildings. At Iversen Landing, they made wagon "tires" and had a special forge to construct the tires before they were mounted to the spokes. (Courtesy of Cheri Carlstedt and Steve Oliff.)

George Call

Built by the Russians, Fort Ross was established in 1812 by Ivan Kuskov. However, by 1839, the Russians had abandoned the fort. It then went through a series of owners, including John Sutter. Eventually Fort Ross was purchased by George Call in 1873. Born in 1829 in Ohio, Call traveled to California in 1852, then moved to South America to help engineer the railroads. While in Chile, he married Mercedes de Leiva and had three children. He then purchased Fort Ross and moved his family to the coast. Call established farming and dairy operations at the fort. He added shipping operations with the addition of a schooner, landing chute, and a wharf for passengers. He also opened a hotel, saloon, post office, and telegraph service. Eventually, he made Fort Ross into a community center of sorts. George and Mercedes had eight more children. In 1903, George Call sold a portion of Fort Ross to the California Landmarks League. (Courtesy of the *History of Mendocino County.*)

Fort Ross Chapel

The most notable structure at the fort, the chapel, is unusual for North America and often photographed. With its landmark "small belfry" a familiar sight along Highway One, the chapel is a mecca to visiting Russians. The greatest efforts made over the years in maintenance and preservation at Fort Ross have been for the chapel. It was constructed by the resident Russians about 1825 with their own funds, and funds donated by visiting Russian officers. In the 1906 earthquake, the chapel's old walls completely caved in and the floors and foundation were reduced to rubble. The roof and the turrets came to rest over the foundation virtually intact. In the spring of 1916, the State Legislature appropriated $3,000 toward its reconstruction. George W. Call's son, Carlos, a strong advocate of the proposal,

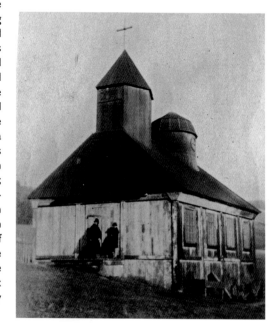

was appointed supervisor of the rebuilding. The chapel's reconstruction mainly involved giving the building a new foundation and walls and bringing the original roof into position. Carlos Call and his local carpenters solved the practical problems of increasing the building's structural integrity, but the chapel's original appearance was changed. A serious error with theological implications occurred when the roof of the cupola was restored in a different style and a Roman, rather than Russian Orthodox, cross was erected on the bell tower. In 1939, a Russian Orthodox cross replaced the Roman cross; however, it was put on the bell tower upside-down due to a carpenter's misinterpretation of a pattern given to him by a visiting Russian Orthodox bishop. A letter to the governor of California signed by several hundred people noting the mistake was forwarded to the carpenter, and in 1941 the Russian Orthodox cross was put up correctly! (Courtesy of Kathy Rubel Dimaio.)

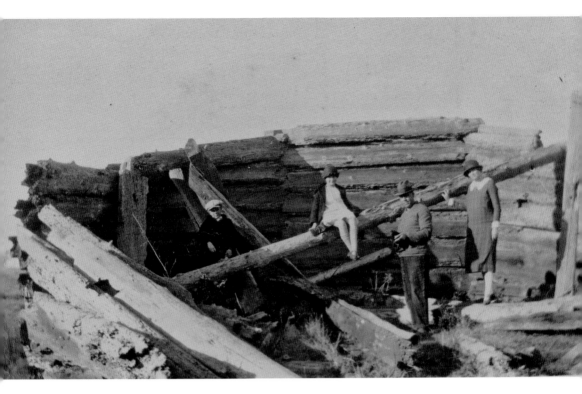

Fort Ross Needing Restoration After the 1906 Earthquake
This photograph, taken around 1920, shows the condition of other parts of Fort Ross after the earthquake. For many years, Fort Ross was almost forgotten. It took the state several years to develop funds for restoration. (Courtesy of Kathy Rubel Dimaio.)

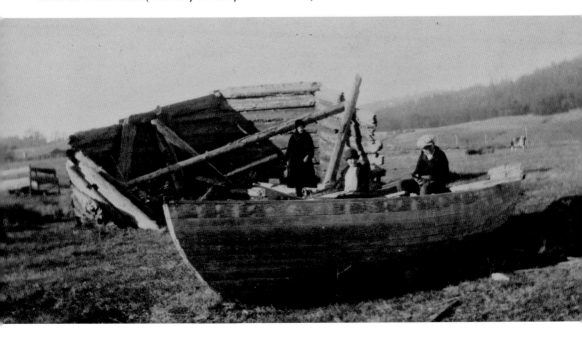

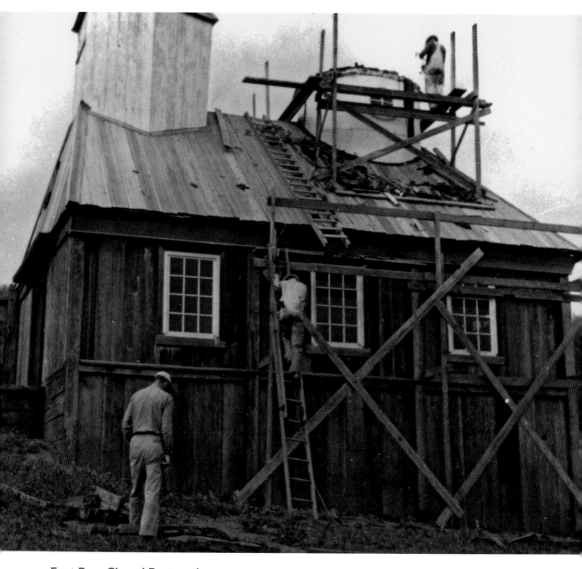

Fort Ross Chapel Restoration
Although the park staff was aware of the changes in design and recommended their correction, the alterations produced by the 1916 reconstruction remained for nearly 40 years. Only as public interest in Fort Ross grew and the study of its building construction became more intensive was the state persuaded to appropriate new funds to bring the building into closer conformity with the original. Finally, in 1955, a second restoration was funded. The walls of the chapel were rebuilt with three windows and the building was correctly aligned with the adjoining stockade as indicated by archaeological excavation, but the elevation of the floor was still high. In 1960, the cupola was replaced with a more authentic Russian roof style, and a small cross was added. This cross was later replaced by a tall Russian Orthodox cross. (Courtesy of the Sonoma County Library.)

Fire in the Chapel

On October 5, 1970, the restored Russian chapel was entirely destroyed in an accidental fire that swept through the building, leaving nothing but a few charred timbers. Once again, supporters of Fort Ross quickly organized to promote a third rebuilding of the chapel. Funds were obtained from a variety of sources: local residents, Russian American groups, and government agencies all contributed. The Department of Parks and Recreation conducted a comprehensive study of the building site based on new archaeological techniques, and developed updated historical data and additional detail on floor alignment, configuration, and use of building materials. The chapel that emerged in 1973 is what is seen today in the compound. (Courtesy of Canyon Construction Company and Evan Johnson, photographer.)

State Park Curator John McKenzie

McKenzie was instrumental in the Fort Ross restorations for over 30 years. Beginning in 1948, McKenzie researched the original Russian structure, supervised restoration, and maintained an archive of architectural findings. (Courtesy of Canyon Construction Company and Evan Johnson, photographer.)

Traditional Hand Tools Used
Canyon Construction Company, who was in charge of the Fort Ross restoration, utilized traditional hand tools in the renovation. This photograph shows the portable mill that was used to make the lumber for the restoration. Logs were put into place, then the portable mill was lined up to slice the log into lumber lengths. (Courtesy of Canyon Construction Company and Evan Johnson, photographer.)

The Rotchev House

Along with the chapel, the structure of most historical interest at Fort Ross is the Rotchev house, an existing building renovated about 1836 for Alexander Rotchev, the last manager of Ross. It is the only surviving structure that contains construction techniques dating back to the Russian era. This structure was known as the "commandant's house" from the 1940s through the 1970s. It was titled the "new commandant's house" in the 1841 inventory to differentiate it from the Kuskov or "old commandant's house." About two years after the Russians departed, William Benitz took up residence in the building. When he married, he enlarged the house by building a two-story addition to accommodate his growing family.

The Benitz family sold the ranch in 1867. The house was also used as a dwelling by James Dixon for a short time after his purchase of the fort in 1867, and by Ada Fairfax, her mother, and her entourage, after her husband's death in 1869. The Russian Rotchev house was the George Call family's dwelling from their purchase in 1873 until early 1878, when they built their own house. It then became a hotel, and was so operated into the early 1900s. It was later occupied by a caretaker family. By the early 20th century, the building was beginning to fall into ruin. Beginning in 1925, steps were taken to restore the Rotchev house to its original appearance. It received a new foundation and a new shingled gabled roof. A kitchen and the two-storied addition were removed in 1926. Other repairs and modifications were carried out after World War II. The long front porch was removed in 1945, a Russian-style hipped roof of long boards replaced the gabled roof in 1948, and new windows and concrete piers were added. In 1971, the Rotchev house was damaged by arson. At that time, it was being used as the Fort Ross Museum, and had many artifacts stored in the attic. The roof burned and most of the artifacts were damaged, lost, or stolen. A comprehensive plan was then drawn to guide its restoration. A new hipped roof was constructed, but the original wall timbers, floor timbers, and ceiling were retained along with the original window and door frames. In 1974, the Rotchev house was reopened to the public, its structure restored as carefully as possible. Future plans may include the restoration of the building's interior as it might have been when the Rotchevs lived there. (Courtesy of Canyon Construction Company and Evan Johnson, photographer.)

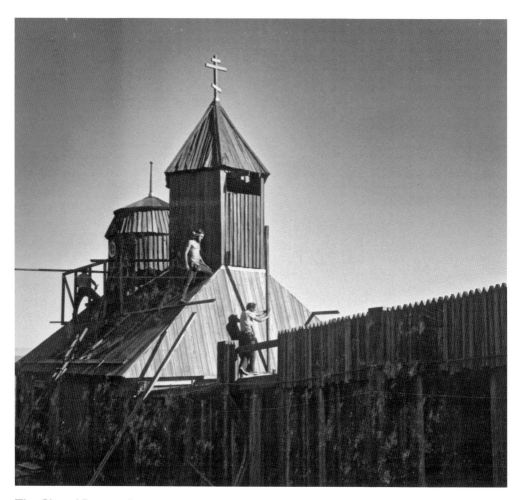

The Chapel Restored
When the Russians left Fort Ross in 1841, they apparently took all the icons with them. They left one large bell, a candelabra, a candlestand, and a lectern, which were destroyed when the chapel burned in 1970. All have been replaced with replicas. The bell that hangs today outside the rebuilt chapel was recast, using the original bell's materials and a rubbing that had been made from the original. It bears the inscription: "Cast in the St. Petersburg Foundry of Master Craftsman Mikhail Makharovich Stukolkin." The bell's deep, resonant chime can easily be heard across the stockade, and twice a year it announces to the public the Orthodox services held in the chapel. (Courtesy of Canyon Construction Company and Evan Johnson, photographer.)

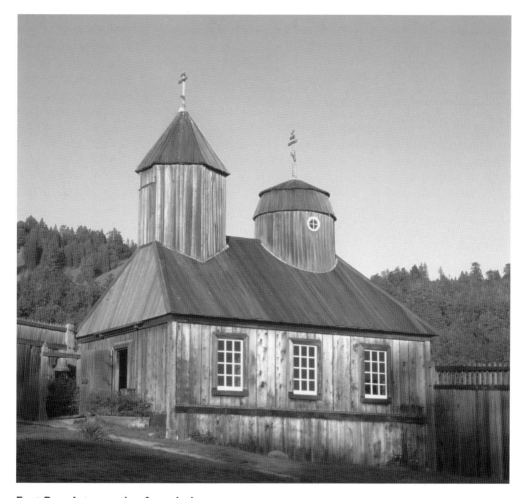

Fort Ross Interpretive Association

The mission of the Fort Ross Interpretive Association (FRIA), Incorporated, is to promote for the benefit of the public the interpretive and educational activities of Fort Ross State Historic Park and Salt Point State Park. Their goals are to preserve and archive historical material associated with Fort Ross and Salt Point State Parks. The group also sponsors and publishes items that increase visitor understanding and appreciation of this area and maintains a library to preserve and archive historical material associated with Fort Ross and Salt Point State Parks. Some of their current projects are: preservation and furnishing of the Rotchev House; a collaborative research project with Russian archives to investigate documents and graphics produced on early-19th-century Russian voyages to the west coast of North America; and furthering acquisition and organization of the Fort Ross library and archives. This library contains 30 albums of archivally preserved historic photographs and almost 3,000 titles in the reference and circulating library. The group also has ongoing projects regarding exhibits and displays, and wayside panels are produced for the park to incorporate updated research as it becomes available. FRIA produces books and brochures about the cultural and natural history of Fort Ross and Salt Point, as well as a twice-yearly historical newsletter distributed to over 400 paying members. One very important project is a cooperative venture with the Native Kashaya community, UC Berkeley, and the state parks to develop a cultural trail in the park. They are also working on restoration and furnishing of the historic Call Ranch House built during the American ranch era in 1878. (Courtesy of Canyon Construction Company and Evan Johnson, photographer.)

John Archibald Hamilton, One of the Founders of Point Arena

Credited with being one of the first permanent settlers of Point Arena, Hamilton was born in 1827 in New Hampshire. He attended Harvard University but was restless and came to California in 1849 on the sailing ship the *Cleora*, which took 160 days. He worked in the mines, and then took up cattle ranching. He and his partner, William Oliver, first travelled to Shelter Cove (Humboldt County). Family legends detail that after his brother-in-law and all his cattle were killed by Native Americans, he quickly traded his land for horses and moved to Point Arena with Oliver. He set up farming near the mouth of the Garcia River and built a home. Shortly after he settled in Point Arena, several families also moved into the area and Hamilton was appointed justice of the peace. He built several schooners and had seven children with his wife Helen Oliver, the last five being born in Mendocino County. His descendants still live in the area. (Courtesy of *History of Mendocino County.*)

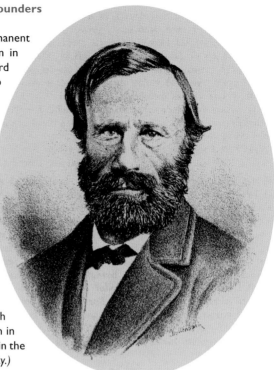

The Hamilton Family
Pictured is the Lovel Hamilton family in the 1950s. Pictured are (left to right) Lovel Hamilton, Arline Hamilton, Eva Hunter Hamilton, Harry Hamilton, and Joyce Pratt. (Courtesy of Arline Hamilton.)

The Hunter Lagoon

The Hunter family also moved into the area soon after the Hamiltons. Samuel Collins Hunter was born in Connecticut. He and his wife settled in Manchester by 1860 and their son, Charles, was born there in 1861. The Hunters had several ranches, one of which was the Hunter Lagoon. This property was a farmhouse surrounded by sand dunes. It is currently a habitat for birds. (Courtesy of Cheri Carlstedt and Steve Oliff.)

The Hunter Women

Charles and Samuel Hunter each established ranches. The Hunter Hill Ranch is still in the Hunter family. Helen Hunter married the grandson of John Archibald Hamilton. Pictured are Arline Hamilton, her mother Helen Hunter Hamilton, and Helen's sister Clara Hunter in 1941. (Courtesy of William Kramer.)

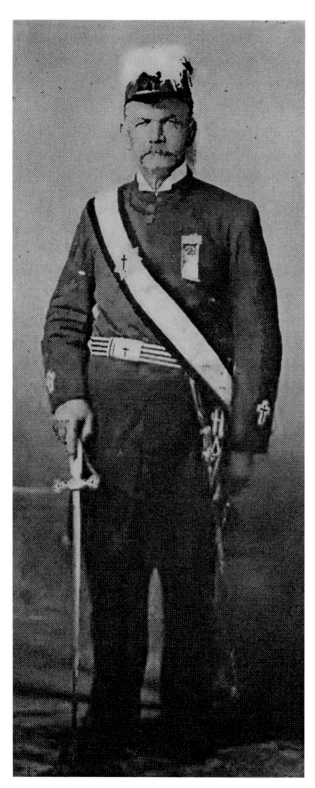

Antone Stornetta, the Beginnings of the Stornetta Family in Mendocino County

Born in Switzerland in 1860, Stornetta came to the United States at the age of 24 on good faith and no money as he had to borrow funds for his passage. After working for $15 a week, he rented a dairy farm in 1886 and built his own creamery in 1902. He owned 300 acres on Alder Creek. He and his wife, Giovannia Biaggi, had seven children. Antone's brother, Raymond, came to the United States in 1881 and also had seven children with his wife Pauline Ghisletta. A.O. Stornetta, Raymond Stornetta's son, was involved in many businesses in the area (Point Arena Hotel, Manchester Store, Boonville Lodge, Point Arena Meat Market, as well as various ranches). He had nine children including a daughter, Dorothy, who married Burney Sjolund. Their son, Alan, and his wife Karen run the S&B Market in Manchester. (Courtesy of the *History of Mendocino County*.)

Manchester Children (ABOVE RIGHT)

Pictured are the students of Manchester School in 1932, many of whom are from the pioneering families, including the Stornettas. Pictured are left to right (bottom row) Anita Morelli, Betty Dahl, Edna Sherwood, Jean Hepworth, Caroline Ainslie, Elmer Scaramella, Norman Stornetta, and Vernon Crispin; (second row) Alma Morelli, Barbara Ciapusci, Dora Stornetta, Tom Biaggi, and Bill Stornetta; (third row) Gladys Stornetta, Norma Scaramella, Bill Walker, and Ken Nichols; (top row) Angela Mazetta, Lou Biaggi, Joyce Bishop, and Bob Wordlix. (Courtesy of Cheri Carlstedt.)

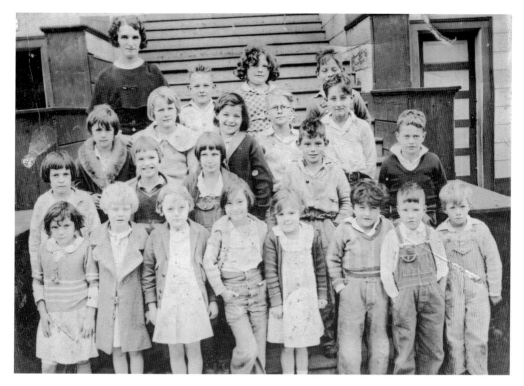

The Stornetta Lands

In 2005, the Stornetta family made an arrangement with the Bureau of Land Management to create the Stornetta Public Lands. The 1,132-acre Stornetta Public Lands include over 2 miles of coastline, the estuary of the Garcia River and adjacent beach, and a small island accessible during low tide. This property is now open to the public. This type of arrangement is a new model for land preservation. Larry and Charles Stornetta have continued to operate their ancestral ranch. The land borders the Pacific Ocean and the historic Point Arena Lighthouse on the west. To the north, it is bordered by Manchester State Park. To the east, it is bordered by State Highway One and Windy Hollow County Road. Land ownership to the south includes a property formerly owned by the US Coast Guard, which now belongs to Mendocino Community College, and another private parcel. The college site, known as the Loran Station, is used for college classes and as a marine research facility. The small island, Sea Lion Rocks, will become a portion of the California Coastal National Monument system. (Courtesy of the BLS.)

41

Mr. and Mrs. Biaggi
Carlo Bartholomew Biaggi came to the United States from Switzerland in 1877. After first settling in the Bodega Bay area, he married Filomena Nonella in 1885. He moved to Mendocino County, established a farm, and erected one of the first creameries in the area. In the 1900 census, the Biaggis lived with the A.O. Stornetta family as A.O. was his brother-in-law. He and his wife had six children. His family still remains in the area. (Courtesy of the *History of Mendocino County*.)

The Zeni Ranch
In the 1800s and early 1900s, several Italian families settled in the Mendocino coastal mountains. They brought with them many cultural traditions. In 1896, Eduino Zeni moved a homestead near the North Fork of the Gualala River. It is now called Zeni Creek. Then, in 1919, he purchased property in the area called Signal Ridge (a narrow ridge top that is now Fish Rock Road, the divide between the Garcia and Gualala River watersheds). Tragically, Eduino and his wife Filomena lost four of their sons to trichinosis poisoning. He sold most of the original homestead the next year but purchased a smaller lot of land. His son, George, was born in 1923. George eventually purchased the entire ranch from his remaining siblings and continued operations on the ranch until his death in 1999. George's children continue to work the ranch today. The Zeni ranch is still known for Christmas trees, the annual chestnut harvest festival, and their grapevines. (Courtesy of *The Ridge Review*.)

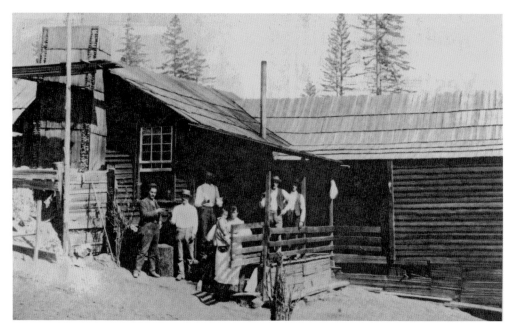

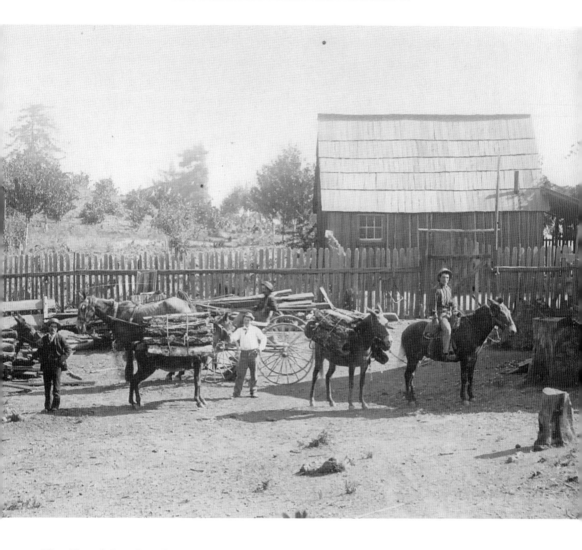

The Gianoli Ranch at Signal Ridge
Batista (Bert) Gianoli came to the United States in 1882 from Italy. Domencio Gianoli came to California to join his brother in 1890. They homesteaded a ranch on Signal Ridge (where several families from the Lombardy province in Italy had settled) and planted 20 acres of Zinfandel grapes. Domencio then sent back to Italy for a wife. His family sent Louisa Togana to California to take Domencio's hand in marriage. Domencio's first job was in the tan bark cutting business. He also made wine. Above the 1,200-foot fog level, is the area was an excellent place to grow grapes. Before Prohibition, wine was sold for 40 cents per gallon. On the ranch, there is an old cantina that has carved initials in the bar. Some initials date back to the early 1800s. Bert Gianoli also brought chestnut seeds with him to the United States. One of his 47 trees was declared by the National Register of Big Trees as the largest chestnut tree in the United States. At that time, the tree measured 73 feet tall and its branches spread 78 feet. During the 1930s, the ranch was used as a hunting camp where room and board was one dollar a day. In 1937, a reporter from the *San Francisco News* interviewed Dominic and Lousia Gianoli. According to Dominic, he was considered one of the toughest men in his country. He recounted to the reporter a legendary story about his bout with an ornery mule. "As a last resort, Dominic grabbed the mule by the ear with his teeth and held on until the mule was subdued." (Courtesy of Cheri Carlstedt and Steve Oliff.)

Everett and Emmet Gilmore

Hiram and Cordelia Gillmore (both from New York) established a family ranch in Manchester near Brush Creek in the 1870s with their children: Emmet Patton, Emma, Effie, Edwin Penn, Elmer Jay Deloss, Edna, Everett E., and Eva. Pictured are (left to right) Everett E. Gillmore, Emmet Ray Gillmore (son of Emmet Patton), and Emmet Patton Gillmore. Hiram passed away in 1907. In his obituary from the *Point Arena Record*, Hiram is described as "respected by all . . . and was generous to the worthy needy. He preferred to give and receive a flower when it could be appreciated rather than placing it on the grave of a departed." (Courtesy of Cheri Carlstedt and Steve Oliff.)

The Gilmore Family

Hiram and Cordelia's children established families on the coast. Emmet P. married Clara Cain (also from a pioneering family). Emma married Archibald Alexander Hamilton, Effie married Elijah Bishop, Edwin Penn married Jennie Andrae, Elmer Jay, called "Jay" married Maggie Jakway, Everett married Leona Ornbaum, and Eva married William Lawson. Pictured are Elmer Jay, "Jay," and Maggie Jakway Gillmore. (Courtesy of Joyce Pratt.)

The Gilmore Store

Later on, Orin Gillmore, son of Edwin Penn Gillmore, formed a partnership with A.O. Stornetta and took over the Point Arena Mercantile Store. He ran it until he was 73 years old. His son, Jack, took over the store until he retired in 1995. This store was the main source of groceries and other supplies for the Point Arena area. (Courtesy of Cheri Carlstedt and Steve Oliff.)

In Loving Memory of

Jack Orin Gillmore

September 30, 1929 — February 16, 2012

He never knew which way the wind blew

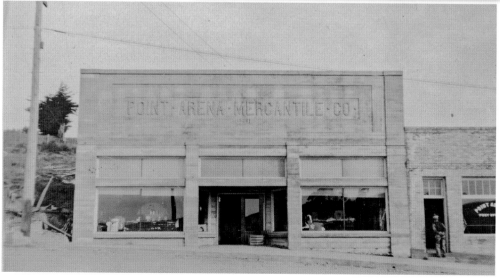

The Point Arena Hot Springs

The Point Arena Hot Springs was a legendary resort near the turn of the 20th century. Around that time, it was very popular to go to hot springs resorts. Legend has it the Native Americans were well aware of the hot springs; however, they were not developed until a hunter, Sam Campbell, shot a bear and it rolled down the mountain and fell into the hot springs. There were several owners over the years, but Doc and Mrs. McCornack played a significant role in turning it into an extensive development during the springs' "boom" period. Pictured is Emily McCornack Halliday (seated in front on the far left in the white hat). The man standing just above her with the white hat and black suspenders is her husband, Al Halliday. (Courtesy of Cheri Carlstedt and Steve Oliff.)

Doc McCornack
Doc McCornack developed and marketed the Hot Springs, offering hunting, music, dance, hiking, and fishing in addition to the springs. Prices were $2.50 per day. (Courtesy of Cheri Carlstedt and Steve Oliff.)

POINT ARENA HOT SPRINGS

Fifteen miles inland on the Garcia River, amid the redwood forests of Mendocino County.

A RUSTIC HOTEL complete in every detail, with large Dining-room and the best of table board. LADIES' RECEPTION ROOM, BILLIARD ROOM, BOWLING ALLEY, a LARGE ASSEMBLY HALL, with a Dance Floor and ANGELUS PIANO. DARK ROOM for photographers' use. In the evening the hotel and grounds are fully illuminated with gas from our own plant. Everything of the most modern sanitary arrangement. Telephone connections. Daily mail, etc., in fact, everything necessary for your comfort and enjoyment.

SWIMMING AND BATHING in the large pool of fresh running water of the Garcia River that flows directly by the hot springs is a luxury and sport few of our guests neglect, so bring your bathing suit.

TUB BATHS in the waters of the mineral hot springs, a natural temperature of 112 degrees, positively cures Rheumatism, Gout, Malaria, Poison Oak, Dyspepsia, Kidney and Liver Complaint, Eczema, etc. These waters are collected in cement tank and then run into the tubs allowing any temperature one desires.

DEER are plentiful and hunting good. Also an abundance of other small game is found while in season. Six hundred acres of this virgin forest as well as several miles of the river belongs to the Hot Springs property, besides the privilege of hunting on miles of the surrounding country.

FISHING with fly or bait in the Garcia River, the famous steelhead trout stream, which flows by the hotel door, is never a disappointment.

MOUNTAIN CLIMBING is easy on good trails to the top of Signal, the highest peak on the coast, and to Beebes, overlooking the ocean, and others near by.

HOW TO GET THERE. By Steamer Sea Foam, sailing every Sunday at 6 P. M. and Wednesday at 4 P. M. from Greenwich Street Dock No. 1 (Pier 23). Returning leaves Point Arena Mondays and Saturdays at 7 P. M. Chas. H. Higgins, Agent, 216 Market St., San Francisco. Phone Kearny 1863. Fare $10.00 for the round trip to the Springs and return. Or you can go by the North Pacific R. R. which connects with the North Coast Stage at Cazadero. Ticket Office, Ferry Bldg.

ARE YOU COMING? Then apply in advance for accommodations at the Springs.

Secure your berths in advance as the steamers are always crowded.

ENQUIRE for full information at the above shipping office or of the proprietor at Point Arena, Mendocino County, Cal.

RATES. $2.50 per day; $12.00 per week; this includes all amusements without extra charge. Open from June 20th to October 1st.

DR. W. A. McCORNACK, Proprietor.

Visitors to the Hot Springs

J.C. Halliday had a stage system so visitors could get to the springs via a schooner from San Francisco. The hot springs were quite popular for 20 years. When Doc McCornack died, his wife left everything there and walked away from the springs. There were also stories of the caretaker being trapped in the buildings by one of the tamed deer that had grown up to be a violent buck. Eventually, the loggers who purchased the land bulldozed and burned the buildings to prevent unwanted visitors. (Courtesy of Cheri Carlstedt and Steve Oliff.)

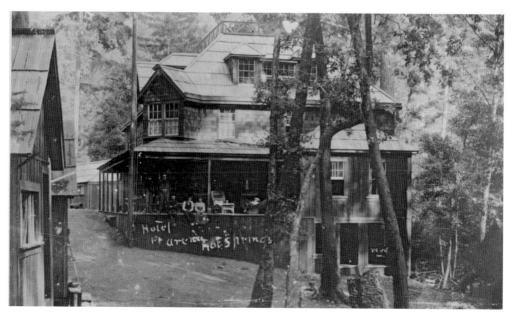

Ancilla Curti Scaramella

Born January 18, 1899, in St. Agata, Italy, Ancilla Curti arrived in New York at the age of 22. She married Ferdinando Domino Scaramella. When she arrived from Italy, she was sponsored by her brother, Joe Curti. She was a proud woman from a peasant village anxious to make a new life in America. Her granddaughter, Lori Bean Radtkey, said of her grandma: "Gramma Ancilla was a very animated, proud, simple peasant from Northern Italy who was the best grandmother in the world. Not a day goes by that she is not with me." (Courtesy of Cheri Carlstedt.)

Ferdinando Scaramella

The son of Dominico Scaramella and Maria Bertola Scaramella, Ferdinando Scaramella was born in Delebio, Italy in 1895. He arrived in the United States in 1910 and began ranching in the Point Arena area. He and Ancilla had four children: Elmer, Raymond, Esther, and Norma. (Courtesy of Cheri Carlstedt.)

The Scaramella Ranch
Shown are Ancilla holding son Raymond, Ferdinando, and an unknown person. The Scaramella story is similar to how many immigrants began in the United States. They had a dairy ranch with 38 jersey cows. They did their own milking by hand, sending the cream to the local creamery and giving the skim milk to the pigs. They also raised chickens and rabbits. Norma, daughter of Ancilla and Ferdinando, refused to let her father kill her rabbits. The rabbits quickly multiplied, hid in the nearby sand dunes then started mating with the wild jack rabbits. Soon there were many mixed breed rabbits all over the area. (Courtesy of Cheri Carlstedt.)

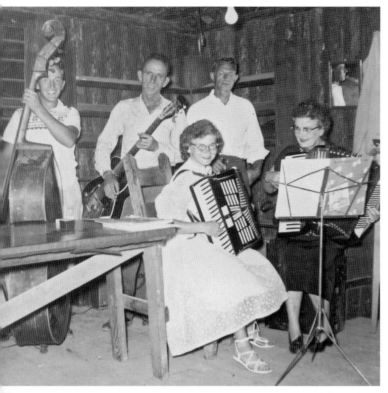

Bertha Campbell Ohlson

Bertha Campbell Ohlson loved to play the accordion. After she and her husband moved to Annapolis, she often played in local dances. In this 1955 photograph, she is playing for the California Conservation Corps Hall dance. Left to right are (back row) Norman, Troy, and Howard; (front row) Shirley McGarvin and Bertha Ohlson. (Courtesy of Dorothy and Gary Craig.)

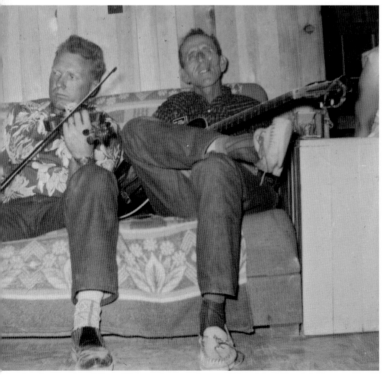

Phillip Robert Campbell

Phillip Campbell, son of Bertha, was a violin player, served in the Air Force, was an accomplished pilot, and started the Annapolis Milling Company in 1946. He was born in Canada in 1920. His family moved to San Diego after his father passed away. While in San Diego, Campbell learned to play the violin and played in the San Diego Junior Symphony as well as at the Hollywood Bowl. When his mother, Bertha, remarried, the family moved to Annapolis. Phil enlisted in the Air Force and became a pilot. On leave, in 1944, he married June Thorpe. (Courtesy of Dorothy and Gary Craig.)

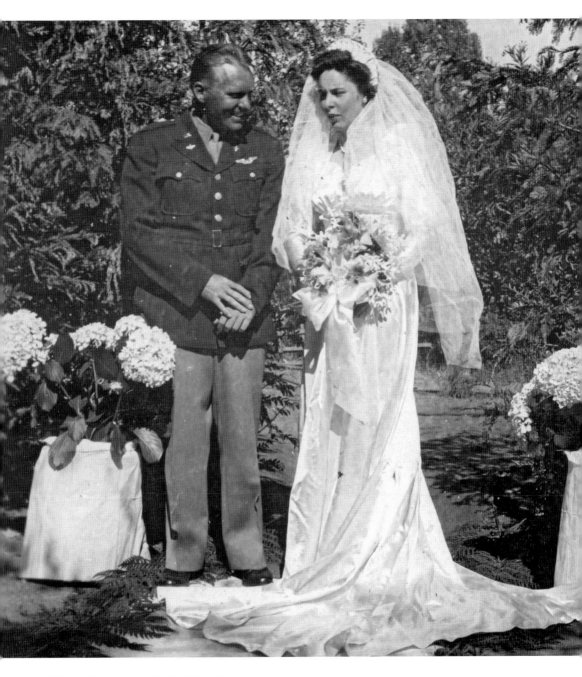

Phil and June Campbell's Wedding
Phil Campbell was sent to England and flew B17s, surviving 17 bombing missions over Germany. At the end of the war, Phil returned to Annapolis and started the Annapolis Milling Company, which was an active mill until it closed in 2001. Still having a passion for flying, Phil became a private pilot and continued to fly his Piper Aztecs until he was 80 years old. He also flew prospective clients above The Sea Ranch. When he died on June 1, 2011, he was 90 years old, and had been married for over 66 years. He and June had three children: Karen, Rex, and Steve. (Courtesy of Dorothy and Gary Craig.)

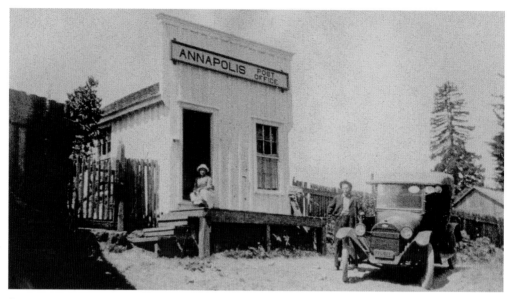

Annapolis Post Office
The Annapolis Post Office was established in 1901. This was considered the town hub and gathering place. This rare photograph shows the familiar post office whitewashed. (Courtesy of Char Ohlson.)

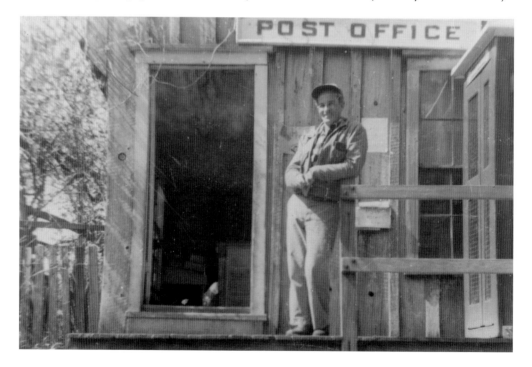

Dick Palmatier
Dick Palmatier carried mail for Annapolis for many years. Since the community of Annapolis is so spread out, the rural mail carriers had a very tough job. One early mail carrier drowned while trying to cross the Gualala River. (Courtesy of Dorothy and Gary Craig.)

Mr. Barney
Mr. Barney was the mail carrier for over 20 years in Annapolis and was very well known . A gentle spirit, he and his wife, Marie, lived next to Horicon School and were well known for their apple trees. Every year, the Barneys made apple cider (and apple jack!) The schoolchildren took field trips to their home to see the process. In the 1970s, Mrs. Barney rescued a wounded deer whom she named "Bambi." Bambi was a familiar figure on Annapolis Road. (Courtesy of Dorothy and Gary Craig.)

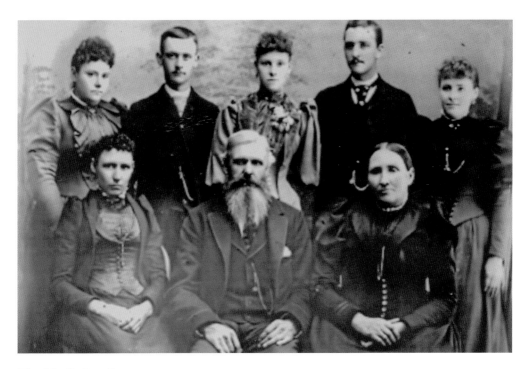

The Ainslie Family
Another pioneer family in the Point Arena area was the Ainslies. Joseph Issac Ainslie was born in Quebec in 1836. He married Helen Martin. Their first seven children were born in Canada: Christina, MaryAnn, Joseph, Elizabeth, David, Eleanor, and James. Their next four children were born in Gualala: Samuel in 1869, Charles in 1871, Eva in 1873, and George in 1875. Sam and Charles Ainslie hauled wood and ties for the Bender Brothers of Gualala. Pictured is the Ainslie family in 1890. (Courtesy of William Kramer.)

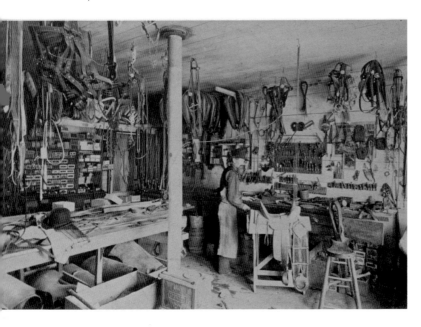

Sam Ainslie's Harness Shop, 1900
Sam Ainslie ran a popular harness shop in Point Arena. (Courtesy of Cheri Carlstedt and Steve Oliff.)

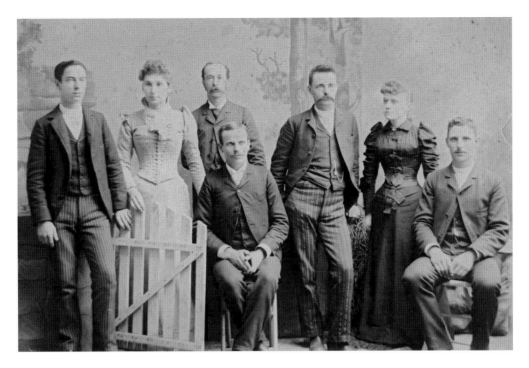

W.W. Fairbanks, Photographer

W.W. Fairbanks, from one of Manchester's oldest families, was a photographer. He was responsible for many of the family photographs in the area. After the 1906 earthquake, he also chronicled the effects of the earthquake on Mendocino County and reported them to the state. His writings and photographs about the effects of the earthquake have become archived and are considered a very important piece of history. The Kelley House Museum in Mendocino has many of W.W. Fairbanks's photos in their holdings. Pictured in this previously unpublished and rare photograph are, left to right, Will Bourns, L. Symonds, W.W. Fairbanks, Wen Willis, George Purcell, Ruth Willis, and Will Symonds. (Courtesy of Cheri Carlstedt and Steve Oliff.)

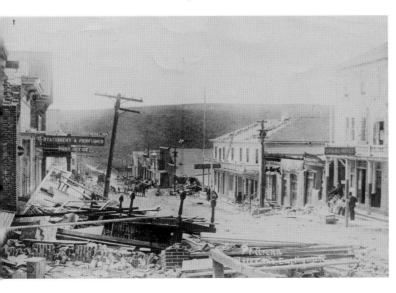

Point Arena After the 1906 Earthquake

In the 1906 earthquake, the Fairbanks home in Manchester was knocked off its foundation. Fairbanks, realizing the significance of the event, began photographing the effects of the earthquake. This photograph shows Point Arena immediately after the earthquake. (Courtesy of Cheri Carlstedt and Steve Oliff.)

Point Arena Record.

POINT ARENA, CALIFORNIA, FRIDAY, JUNE 28, 1912.

OR THE NAVY

REMINISCENCES OF A PIONEER

By COLONEL WILLIAM THOMPSON

Editor Alturas (Cal.) Plaindealer

THE BANAN IN COSTA

CHAPTER XIX.

REIGN OF THE VIGILANTES.

(CONTINUED)

Every newly settled country has had to deal, to a greater or less extent, with lawless characters. Generally these outlaws have been brought into subjection and destroyed under the operation of law. Occasionally, however, this, from one cause or another, has been impossible. It is then that citizens, unable longer to bear the outrages committed by desperate criminals, take the law into their own hands and administer justice according to their own ideas of right, and without the forms of law. Such occasions are always to be deplored. They arise from two causes, the mal-administration of justice and blodness of criminals whose long immunity from punishment renders them reckless and defiant of both law and the citizens.

Such conditions existed in the late 70's and early 80's in that portion of Eastern Oregon now embraced in the county of Crook. During several years desperate characters had congregated in that section. From petty crimes, such as the stealing of cattle and horses, they resorted to bolder acts, embracing brutal and diabolical murder. For a time the citizens appeared helpless. Men were arrested for crime and the forms of law gone through with. Their associates in crime would go into court, swear them out and then boast of the act. On one occasion I went to one of the best and most substantial citizens of the country, Wayne Claypool, and asked him about an act of larceny of which he had been

them we were after Langdon and Harrison, and did not wish to harm any one else, but that if one of them stuck his head out of the cabin he would get it blown off.

We had got the horses, blankets and rifles of the murderers, and now began the watch that was to last until daylight. The wind was fierce, even in the shelter of the timber, and a cold snow drifted over us. We had not only to guard the house, but the shed in which the horses were tied as well. Besides, we did not know what would happen when daylight came and they should discover that our party numbered five, instead of twenty, as they supposed. When daylight finally came I went to the door and told those inside to come out and to come out unarmed. They obeyed at once, and eleven men filed out of the cabin. Of the number, there was but one that any of us had ever seen before, or to my knowledge ever saw again. The one was a brother of Langdon, and we at once placed him under arrest that he might not render his brother assistance.

We had agreed on our plans during the night, and taking young Langdon, Long and I started back to town, while the others began to circle for tracks of the fugitives in the snow. I should have stated that when the shooting began the night before, Mr. Johnson mounted his horse and rode home at top speed. Arriving there, he sent one of his sons to Prineville and the other up the Ochoco, telling them that we had the murderers surrounded and were fighting as long as he was in hearing, and were in need of help. Going up the mountain I discovered the tracks of the fugitives in the snow, and as we reached the summit we met 75 or 80 men coming out to help us. I turned them all back, saying the murderers had

A BANANA PLANTATION

ALL Costa Rica is divided into two parts, that which is the scene of the operations of the United Fruit company, and that which is not. The first is becoming Americanized; in the second, European nations now have the advantage in trade.

In the banana country the fruit com-

England takes year and pay than the Unit zilian coffee. strong and bla Jose, and to superior to th ed in America is better with

William Hanen and the *Point Arena Record*

William Hanen was born in 1860 in New York and came to California when he was 21. In 1887, he took over the weekly newspaper, the *Point Arena Record*. He published the paper for 35 years. The newspaper detailed current events as well as social items and was especially important in this isolated area of the coast. He also served one term as state assemblyman and was first treasurer for the City of Point Arena. (Courtesy of Cheri Carlstedt and Steve Oliff.)

Ralph McMillen

Ralph was the son of Hiram and Sarah McMillen, who settled in Sonoma County in the late 1800s. The McMillens were a large family who first settled in Bloomfield, near Tomales, then moved to Annapolis. Ralph was born in 1900. He was drafted into World War I and later married Sadie in 1929. He first partnered with Orin Gillmore in the Point Arena Mercantile Store. He then moved into his own store, the Point Arena General Store and ran that for many years. Ralph died in 1971. (Courtesy of Cheri Carlstedt and Steve Oliff.)

RALPH MC MILLEN

When you came to Point Arena
 You were a young ambitious lad
You worked hard sixteen hours a day
 And thought it not too bad.

In nineteen twenty-nine you married Sadie
 Who has been with you through the years
She has shared each of your joys
 Your heartaches and your tears.

When times were either good or bad
 She has given her best to you
A son of which you are quite proud
 And a lovely daughter too.

You have made one accomplishment
 Few men these days can do;
You have been in the same business
 For fifty years plus two.

You have faced up to life's trials
 You would not admit defeat;
You have toiled until you had callouses
 On your hands and on your feet.

You have helped a lot of people
 You have worked your whole life through;
And this world would be a better place
If there were a lot more men like YOU.

 By: W.A. (Pappy) Yocum

Written for his 70th Birthday.

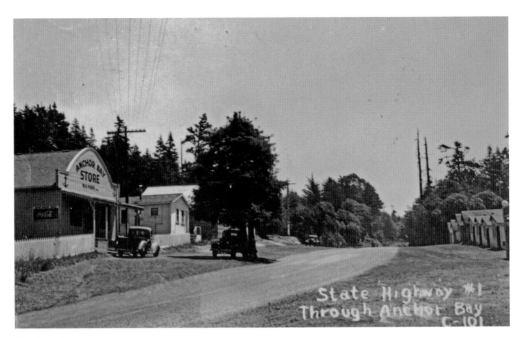

Anchor Bay
Dave Berry owned the Anchor Bay Store in the tiny town of Fish Rock. When Mr. Berry died, his daughter asked her father's friend, William Pierce, to take over the store. Pierce developed the town and within a few years, after the coast road was paved, Anchor Bay grew to be quite a tourist spot, with a store, gas station, dance hall, and rental cabins. (Courtesy of Cheri Carlstedt and Steve Oliff.)

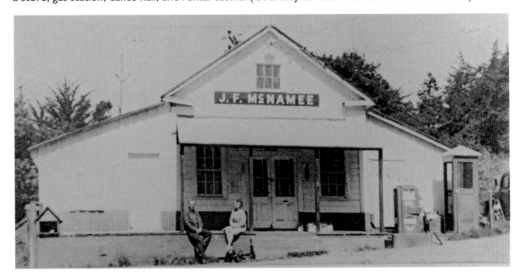

McNamee's Store
Two miles north of Anchor Bay, Jim McNamee developed his own small store in 1910, which would later become a notable fixture on the coast. When the store closed, much of its contents were donated to the Mendocino County Historical Society. A re-creation of this store is in the Willits Museum. This photograph shows the store in about 1950. McNamee is on the left and his wife is on the right. (Courtesy of Cheri Carlstedt and Steve Oliff.)

Fisk's Mill
John Fisk started a mill just north of Fort Ross. Fisk's Mill had a small store, post office, and a telegraph office. Fisk is on the far right in this 1904 photograph. (Courtesy of William Richardson.)

The Galletti Family
As written in the *History of Mendocino and Lake Counties*, "Among the men who have come to Mendocino county from sunny Italy and become successful business men is Charles Galletti, who came to Point Arena in 1893." Galletti worked first in a Point Arena dairy, then rented ranches. In 1913, he went into the hotel business with A.O. Stornetta and the butchering business. Galletti married Carrie Stornetta. They had eight sons as shown in this photograph. Left to right are (back row) Chet, Leo, Clarence, and Henry; (front row) Warren, Ted, Elmer, and Charlie. Ted Galletti was a Mendocino County supervisor. (Courtesy of Cheri Carlstedt and Steve Oliff.)

Mart T. Smith and the Point Arena Wharf
In 1866, Smith was granted a 20-year wharf franchise to the Point Arena Wharf from the State of California. Until that time, vessels had to be loaded by small boats that carried freight out to the schooners. Without a wharf, Point Arena would not have progressed to become an important shipping port. (Courtesy of the *History of Mendocino County* and Cheri Carlstedt and Steve Oliff.)

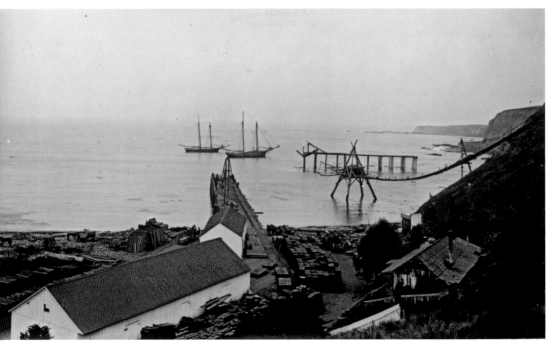

Jefferson Davis, Early Hero
In 1896 lighthouse keeper Jefferson Davis saw the ship the *San Benito* go down among the rocks. Although there were several hundred people on the beach, he could only convince two men to accompany him out to help. They were not able to rescue the men, but kept trying. The men from the ship were stuck on the rigging. Mr. Davis was awarded the Gold Badge of Courage. (Courtesy of the *San Francisco Call*.)

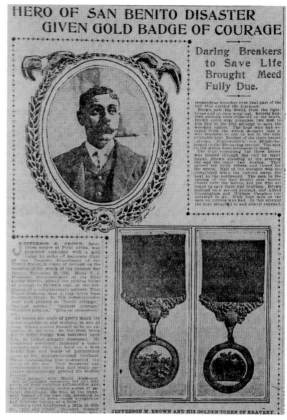

Point Arena Life Saving Station
Between 1858 and 1880, 15 vessels wrecked off of Point Arena. Because of this, citizens started activism to gain a life saving station. In 1900, their wishes were granted. Finally, in 1903, the life saving station was built. Eventually, the US Coast Guard took over the responsibilities. (Courtesy of Cheri Carlstedt and Steve Oliff.)

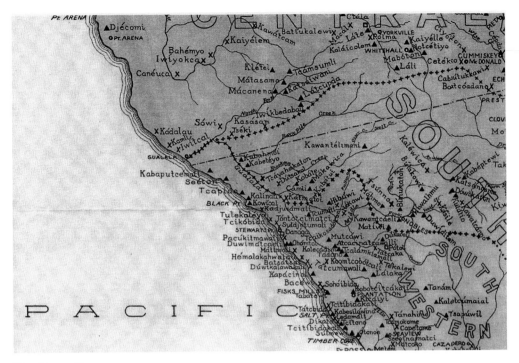

The Pomo Map

The first inhabitants of the Sonoma Mendocino Coast were the Pomo. As seen in this map, the Pomo had villages all over the coast. There were many villages in The Sea Ranch area, most particular the village of Kowical at Black Point. The Pomos preferred the open coast to the shadowy redwoods. The Southern Pomo got along well with the Central or Northern Pomo even though they all spoke slightly different dialects. (Courtesy of the Bancroft Library.)

Pomo Basketry
The Pomo are known for their superb basketry. This photograph, from the Point Arena - Manchester Rancheria, shows the size of the basketry. The Point Arena - Manchester Reservation is 364 acres. The current population of the tribe is about 500. Nelson Pinola is the current chairman of the tribal council. Reportedly, one of the oldest residents of the area was from the reservation. "Old Captain" died in 1900 and was reported to be 110 years old. (Courtesy of Cheri Carlstedt and Steve Oliff.)

CALIFORNIA NATURAL HISTORY GUIDES

CALIFORNIA INDIANS and THEIR ENVIRONMENT

An Introduction

KENT G. LIGHTFOOT and OTIS PARRISH

Kashaya and Otis Parrish

The Kashaya Pomo reservation is located near Stewarts Point off of Highway One in Sonoma County. Otis Parrish grew up at Kashaya, received his degree from Sonoma State, then attended graduate school at UC Berkeley in anthropology. He worked for many years at the Phoebe Herbst Museum of Anthropology. He also has worked very closely with the Fort Ross Interpretive Center. He has supervised excavation and documented many Pomo findings. He has written books and many articles. (Courtesy of the Fort Ross Interpretive Center.)

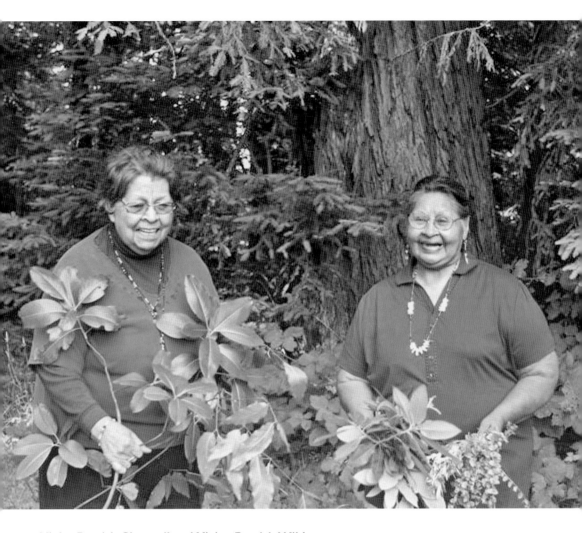

Violet Parrish Chappell and Vivian Parrish Wilder
Daughters of Essie Parrish, Chappell and Wilder are Kashaya Pomo who work to maintain ancient traditions. They have fought against development that has threatened many aspects of ancient Pomo traditions. The building of Lake Sonoma severely limited where the Pomo could gather plants for basketmaking. In recent months, Chappell and Wilder have been fighting the conversion of ancestral land to vineyards. (Courtesy of Kathy Rubel Dimaio.)

Beginnings of The Sea Ranch Design
Al Boeke is credited with the idea of The Sea Ranch. Alfred Anton Boeke was born in Colorado in 1922. He received his BA in architecture from the University of Southern California in 1948. As Vice President of Development for Oceanic Properties, Inc., he was given the responsibility of locating a location for a new housing development. Al Boeke felt the Del Mar Ranch, with its views, meadows, and ridges, was the perfect location for a second home community. He discovered the Del Mar Ranch while flying over the coast on a Pacific coast tour. Previous to The Sea Ranch, Boeke had directed the development of Mililani, a community in Hawaii. After persuading Oceanic Properties to purchase the Del Mar Ranch, he put together a team to develop the property. He first chose renowed landscape architect, Lawrence Halprin. (Author's collection.)

Lawrence Halprin
Halprin is one of America's most well known landscape architects. Among his projects include the Franklin Roosevelt memorial (reportedly his personal favorite), Ghirardelli Square in San Francisco and parts of the Bay Area Rapid Transit (BART) System. His most famous project, however, was The Sea Ranch. In 1961, Halprin was asked to develop a master plan for the Del Mar Ranch. After spending a great deal of time on the property, Halprin's general theme of "living lightly on the land" emerged. He studied the indigenous Pomo culture as he valued their spiritual relationship with the land. Some of his driving principles were: keeping the coastline and meadows open, keeping the houses back of the trees and cluster other homes on the ocean terrace. (Author's collection.)

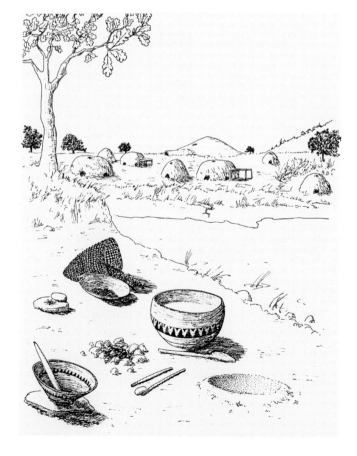

The Ohlson Family
Ernest Ohlson came to the United States in 1889, landed at Bourn's Landing (north of Gualala), and bought 160 acres of land in Annapolis. He planted a prune orchard and had four children: Ed, Ernie, Elmer, and Chester, all born in Annapolis. The Ohlson brothers purchased the Del Mar Ranch (now known as The Sea Ranch) in 1941 from an estate sale. The family ran sheep on the ranch until the 1960s. (Courtesy of Junior and Char Ohlson.)

Ernie and Ches Ohlson
After he and his brothers purchased the Del Mar Ranch, Ernie Ohlson stayed at the ranch in Annapolis, raising sheep. The Ohlson family later sold the Del Mar Ranch to Oceanic Properties in 1963. (Courtesy of Junior and Char Ohlson.)

67

The Del Mar School

The Del Mar School opened in 1905 for the Bender Brothers mill. The school closed after the mill burned in 1915. This 1964 photograph shows the Del Mar Schoolhouse with Lovel Hamilton (who attended the school as a child.) Later, residents of The Sea Ranch restored this old schoolhouse. (Courtesy of the Joyce Pratt.)

MLTW

MLTW—the team of architects Charles Moore, Donlyn Lyndon, William Turnbull, and Richard Whitaker—was founded in Berkeley in 1962. These renowned architects emphasized the use of elements within their projects that encouraged human interaction. Upon Halprin's recommendation, MLTW were the first The Sea Ranch architects. In 1991, MLTW was awarded the American Institute of Architects 25 Year Award for their design for Condominium One. This very prestigious award, which recognized architectural design of enduring significance, was previously awarded to Rockefeller Center, the Vietnam Veterans Memorial, and others. (Courtesy of Jim Alinder.)

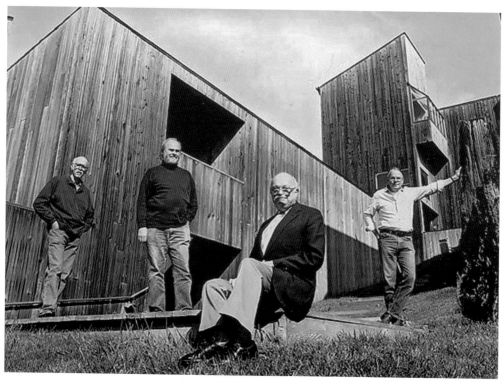

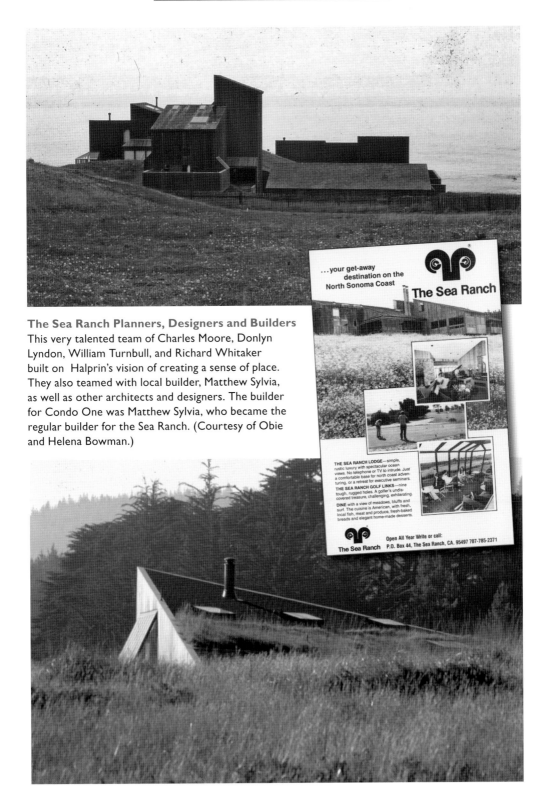

The Sea Ranch Planners, Designers and Builders
This very talented team of Charles Moore, Donlyn
Lyndon, William Turnbull, and Richard Whitaker
built on Halprin's vision of creating a sense of place.
They also teamed with local builder, Matthew Sylvia,
as well as other architects and designers. The builder
for Condo One was Matthew Sylvia, who became the
regular builder for the Sea Ranch. (Courtesy of Obie
and Helena Bowman.)

...your get-away
destination on the
North Sonoma Coast

The Sea Ranch

THE SEA RANCH LODGE—simple,
rustic luxury with spectacular ocean
views. No telephone or TV to intrude. Just
a comfortable base for north coast adven-
turing, or a retreat for executive seminars.
THE SEA RANCH GOLF LINKS—nine
tough, rugged holes. A golfer's undis-
covered treasure, challenging, exhilarating.
DINE with a view of meadows, bluffs and
surf. The cuisine is American, with fresh,
local fish, meat and produce, fresh-baked
breads and elegant home-made desserts.

The Sea Ranch Open All Year Write or call:
 P.O. Box 44, The Sea Ranch, CA. 95497 707-785-2371

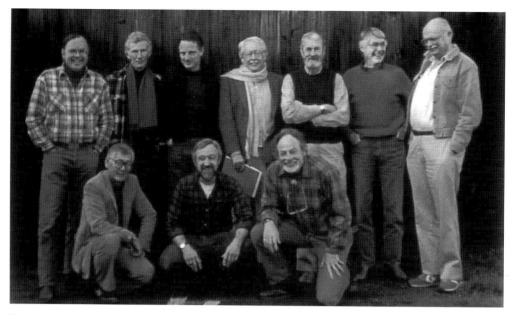

Early Sea Ranch Consultants
This photograph, taken in 1988 in front of Condominium One, shows the early Sea Ranch consultants except for two very important exceptions: Donlyn Lyndon and Richard Whitaker are not pictured. Pictured are left to right (top row) William Turnbull, Jack Coener, Donald MacDonald, Jim Burns, Joe Esherick, Al Boeke, and Charles Moore; (front row) Hideo Saaki, Revergy Johnson, and Lawrence Halprin. (Courtesy of the Sea Ranch Association.)

Joseph Esherick – the Hedgerow Homes
Born in 1914, Joseph Esherick was the cofounder of University of California–Berkeley's College of Environmental Design. He collaborated with the MLTW design team to create the "Hedgerow Homes." (Courtesy of Obie and Helena Bowman, photograph by Robert Foothorap.)

Obie Bowman

Obie Bowman attended USC, UC Berkeley and Arizona State universities studying architecture. After apprenticing with architects in Los Angeles, he moved to the Mendocino coast and started his own practice. In 1973, he opened his office at The Sea Ranch. Bowman says about his work: "The values I bring to my work have grown out of my own experiences and reach back to some of the fondest memories of youth… a desire to build and a need to work with rather than against the natural landscape." His work has been featured in many publications and he has won numerous awards, including awards from the American Institute of Architects (AIA), Sunset and Builders Choice. In 2008, he was inducted into the AIA College of Fellows. Obie is married to Helena, who taught English at Point Arena High School while they lived on the coast. They have four children. Top photo (Courtesy of Obie and Helena Bowman, photograph by Robert Foothorap.) Right (Courtesy of Obie and Helena Bowman.) Below, pictured is Highway One with Condominium One in the distance in 1967. (Courtesy of Obie and Helena Bowman.)

71

Joanna McLaughlan

MacLaughlan was the first female copy boy at the *Cincinnati Times Star* during World War II. She then became a reporter. When she and her husband retired and bought a lot at Sea Ranch, she realized the area did not have a newspaper. According to her son Steve, Joanna started the paper on her dining room table. The first issue came out in April 1969. Immediately, she had 250 paid subscribers. MacLaughlan's dream was to produce something "more than a bulletin board." (Courtesy of Steve MacLaughlan.)

Steve MacLaughlan, Publisher of the ICO

MacLaughlan, son of Joanna, worked on the paper during school vacations. After studying business at Santa Clara University, Joanna needed his help and in 1989, Steve became editor and publisher. (Courtesy of Steve MacLaughlan.)

Independent
Coast Observer

VOLUME 1, NUMBER 1 THE SEA RANCH, CALIFORNIA APRIL, 1969

The Sonoma-Mendocino Coast is an awesome sight whether viewed from the ocean or from the shore. Every Coast Observer is aware of that. Even this fellow.

Winter Was Wet and Windy Wild And Wooly but now Spring has come to the Coast

The wild iris are blooming, the air is brisk and invigorating, the ocean waves a-bounding, the night sky is a happening of stars, the streams are clearing but still full of water.

On the weekend of March 22-23 it was shirt sleeve weather on the coast with warm temperatures under clear and sunny skies. Driving down the road, it was good to see the sheep with their specially heavy coats (as befits after a severe winter), to see the young lambs which one has watched since they were babies this winter gamboling on the green.

It has been an exciting winter on the Coast. But now that Spring has come!

Unification of School Districts is Big Issue In April Election

One of the more interesting, and controversial issues facing voters in the April school board elections centers on the unification proposal. Voters in the Point Arena elementary school district will be asked to decide whether to join together in a unified elementary school district.

In addition to local elementary school board elections there will be an election of a slate of seven, representing the various districts involved, who will serve as a board for the unified school district if the unification issue passes.

Proponents of unification express concern over the present situation wherein uneven opportunity for an adequate education in the various elementary schools feeding into the Point Arena High School makes it difficult for both the students and the teachers at the high school level. A wide diversity of reading, math skills, etc. exists in students arriving at the high school, proponents of unification aver, and by pooling resources in funds, materials, and teaching resources a more efficient and higher quality program for all elementary school children would result.

Opponents of the unification measure indicate some fear of loss of autonomy in each district, a concern that some schools would be closed and the children bused to other schools. Opponents suggest that more study is needed on the measure before it is passed by the voters. This is the third time the issue has come before the electorate within the past five years, according to information received by the ICO.

Ten candidates have filed for the seven seats on the board of the proposed unified school district, and two

(Continued on Page 2)

About that Fellow Above

The marvelous creature who looks like he just rose from the Pacific waters to aid in observing the coast, is really an outdoor ceramic pot which graces the gateway of the T. Carson O'Connell entrance, houses a light to direct visitors to the residence and has brought much attention from sight-seers in the area.

Eric Norstad, a well known potter from Corte Madera made the ornaments for Mr.

O'Connell, achieving a sea-like appearance to them as if they had been dug up out of the ocean. Aside from casseroles, plates and mugs, Mr. Norstad does custom work on chimney pots and larger architectural items, according to Mr. O'Connell.

The staff photographer, while cruising the coast for interesting pictures, was struck by the unusual and handsome pots and took their pictures from various angles. The editor, upon seeing the results, saw in this one camera angle the perfect symbol of the Independent Coast Observer, looking out to see the sea, and appearing a bit awed by it all.

Two doctors In Practice On the Coast

A new doctor is soon to open offices in Gualala, it has been learned, by the INDEPENDENT COAST OBSERVER which will bring the total number of practicing physicians along the coast to two.

Dr. Creighton Brigham, an osteopathic physician and surgeon comes to the area from Los Angeles and will be located in the new office building across the road from the Gualala Building Supply.

Dr. J.S. Woodruff, M.D. has been tending the medical needs of the coastal area for a year or two with offices in Point Arena and at The Sea Ranch. Dr. Woodruff came to us from Honolulu and lives in The Sea Ranch.

A schedule of Dr. Woodruff's office hours will appear elsewhere in the I.C.O. and the editor will publish the office hours of Dr. Brigham when this information is available.

Salmon Come Home! In About 3 Years

The Gualala River came in for its share of salmon this spring when Game Warden Raymond Koenig, assisted by some no doubt far-seeing fishermen, planted 40,000 year old silver salmon in the North Fork. The fingerlings were raised in the Darran Springs hatchery to eight inch size, after being hatched at Shasta from eggs gathered last year in the Noyo River.

Part of a four year program begun in 1968 to restore the silver salmon to streams along the coast, the fish are expected, after a confused childhood, to remember the Gualala as home and to return after a three year sojourn in the ocean. At that time they should be handsome ten to twenty pounders and fishermen in the area will be waiting to welcome them with inviting bait.

Hopefully the fish will not have memories extending back too far, and end up in the Noyo, or try to beat their way to Shasta!

No Options By Oceanic

The Sea Ranch holds no option on the property south of The Sea Ranch, according to Joe McClelland, spokesman for Oceanic Properties. When asked about the rumor that Oceanic holds an option on the coastal area, Mr. McClelland pointed out that the extensive Sea Ranch is still being developed and that Oceanic has not decided in which direction it will move in the future. Possible developments in Marin

County and elsewhere are contemplated and Oceanic has no plans at present to purchase any more land on the Sonoma Coast.

Big Crab Feast Coming Up

"All the crab you can eat" has been promised by a spokesman for the V.F.W. Crab Feast to be held on the evening of Saturday, May 3 at the Veteran's Memorial Building in Point Arena.

Buffet tables will be set with salads and bread and huge trays of crab are kept filled at the tables of the diners.

Crab Feasts are held three or four times a year by the V.F.W. and are looked forward to eagerly by all who have been there before.

The public is invited and visitors to the area are welcome to attend. Tickets will soon be on sale throughout the area.

Canoeing on the Gualala is great- but Watch it!

Canoeing down the Gualala is a seasonal sport. Last summer George Comstock and his family, of Sculpture Point Drive in The Sea Ranch put their canoe in the South Fork of the Gualala at the Annapolis Bridge and it took them five hours to paddle and portage their way down to the mouth of the Gualala.

After the winter rains had set in, George and his family made a faster trip. In the fast moving river it took only an hour and a half to complete the same distance.

This trip in swift water is not recommended for the neophyte but by next month the river should be just about right for an experienced crew to dip a paddle in this stream. (Ed note: We have just been advised not to encourage anyone to take this trip unless he really knows how to handle

The South Fork of the Gualala passing under the Annapolis Road Bridge, was calming down in March 1969.

a canoe and has had advice about the route. Better to learn how to handle the craft in a peaceful basin before attempting more adventuresome waters. We'll check with George before the next issue of ICO and report).

NEXT MONTH In the INDEPENDENT COAST OBSERVER
More on what Wandering Albatross
The story of Benny Bufano's head
Gourmet recipe
Details of Photo Contest
Other exciting items too numerous to mention

The *Independent Coast Observer*—the ICO

A newspaper is the glue that holds a community together. This is the first issue of the ICO from 1969. The newspaper is now a monthly publication. (Courtesy of Steve MacLaughlan.)

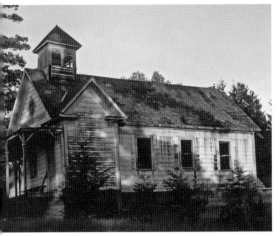

Horicon School Before Restoration

The Annapolis Historical Society was created in 1979. The old Horicon Schoolhouse, on land belonging to the Patchett family, was deeded to the society in 1980. The schoolhouse was the society's first project as it was in poor repair. In fact, it was in such poor repair that the county building inspector reported the building had to be torn down. Historical society members refused to believe the building could not be restored and dedicated many hours of hard work repairing the schoolhouse. The restoration was so successful the building inspector wrote a letter of apology and the group received an award from the Conference of California Historical Societies for their efforts. (Courtesy of Annapolis Historical Society.)

Steering Committee of Annapolis Historical Society

Bill Conroy was the president of the Annapolis Historical Society when it was formed. He drove many of the group's efforts. Conroy was both principal and teacher of the original Horicon School in the late 1940s. This photograph is of the first steering committee, which organized and incorporated the Annapolis Historical Society. Pictured are (left to right) Jessie Evans, Lillian Del Maestro, Judy LaFore, Richard Ashcroft, Bill Conroy, Brother Toby McCarroll, and Cliff Putnam. Absent was Phil Crosby. (Courtesy of Annapolis Historical Society.)

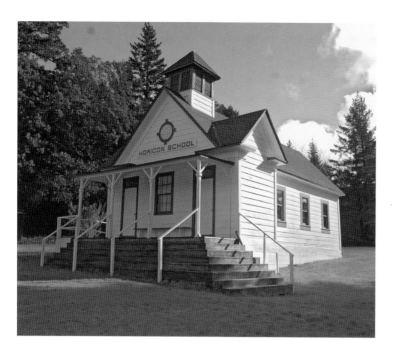

Horicon School, After Restoration The Horicon School is now used for special events, history field trips, and annual events of the Annapolis Historical Society. Inside the school, the halls showcase historical photographs from the society's collection. (Author's collection.)

Dorothy and Gary Craig

The Craigs are very active members of the Annapolis Historical Society and have contributed greatly to the community. They also own the Annapolis Post Office building. Dorothy's mother (Alice Fiscus) and grandmother (Mary McMillen Fiscus) were past postmistresses and Dorothy's grandfather, George Fiscus, built the post office. They have made a very strong effort to preserve history in the area. (Courtesy of Dorothy and Gary Craig.)

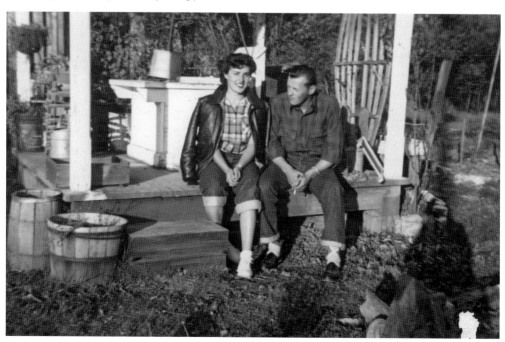

Char Ohlson
Ohlson is the president of the Annapolis Historical Society. Every November, the group hosts a Thanksgiving potluck that is open to the entire community. Ed Garrett is the genial announcer. (Author's collection.)

Nip Rasmussen and Junior Ohlson
The Rasmussen family was one of the early families in Annapolis. They lived near the Haupt ranch, Kashaya, and Stewarts Point. The children attended the now defunct Dirigo School. Pictured are Nip Rasmussen (left) and Junior Ohlson (right). (Author's collection.)

Annapolis Post Office Retirement
The Annapolis Post Office was closed in the fall of 2011. This photograph shows the community of Annapolis honoring the post office and the Craig family. (Author's collection.)

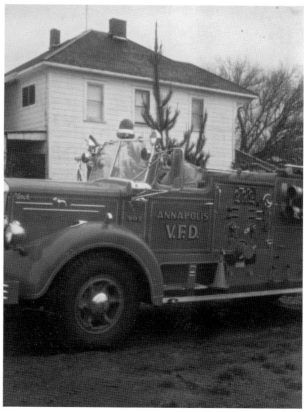

Annapolis Volunteer Fire Department
In remote rural communities like Annapolis, firefighting services are not usually available and volunteers are needed to handle most emergencies. Many individuals were instrumental in organizing the first Annapolis Volunteer Fire Department. (Courtesy of Dorothy and Gary Craig.)

**First Officers of
Gualala Arts**
In July 1961, the first
officers of Gualala Arts
were Bertha Ohlson and
Kathy Rubel. (Courtesy
of Kathy Rubel Dimaio.)

**Art in the Redwoods
First Show**
The first show featured
20 artists and was held
in the community center.
The focus of the show
was on the local artists
as well as gardening.
(Courtesy of Kathy Rubel
Dimaio.)

78

Betty O'Neil and Kathy Rubel Dimaio—Top Hat Award

In August 2011, O'Neil and Dimaio were honored with the Top Hat award for coming up with the idea of Art in the Redwoods. O'Neil had attended a garden show in Oakland and wanted to recreate it in Gualala. She had no idea that, 50 years later, the Art in the Redwoods show would draw hundreds of people to Gualala each year. The annual art show has changed a great deal in the last 50 years. Now, artists from all over the country apply to be a part of the show and tourists flock to Gualala to see the show each August. O'Neil and Dimaio were honored recently at the Gualala Arts Center building. (Courtesy of the *Independent Coast Observer* and Gualala Arts.)

PAGE 12-ART IN THE REDWOODS INDEPENDENT COAST OBSERVER AUGUST 19, 2011

The first show: art and garden

By Frank Healy

Most agree Art in the Redwoods (AIR) began 50 years ago in 1961, but there are different versions about where it began.

Betty O'Neil and Kathy (Rubel) DiMaio, honorees at this year's Top Hat dinner, were there. Both remember that the 1961 AIR took place in the Gualala Community Center.

O'Neil, an ardent gardener, was inspired to set up a show at the Community Center after attending the Oakland Flower Show. It took weeks for planning and decorating. An artificial redwood tree dominated the center of the Community Center floor. A wood framework was covered in bark donated by Norm Reuter. Fresh cut branches formed the limbs.

Around the central tree, flower arrangements by Jesse Cranston, Bertha Ohlson, Kathy DiMaio and Mae Enos sat on bark covered frames built to resemble tree stumps. Works from local artists hung by O'Neil were displayed along the walls.

Refreshments consisted of homemade cakes and desserts served with coffee.

No prizes were awarded at that first successful event.

Like the symbolic redwood centerpiece in 1961, AIR has grown from a tiny idea in the minds of two women to a major annual August weekend for visitors, vendors and artists. It also is integrally linked to Gualala Arts, an organization with more than 1,600 annual activities,

and it helped spur the effort to create the current Art Center building.

In recent years the four-day event includes the Top Hat dinner, a champagne preview, a vendor fair, and the exhibit of fine art. The origin of all these activities can be found in previous shows. The landscaped Gualala Arts Center grounds echo the garden emphasis of that first show.

The honorees of this year's Top Hat Dinner are most fittingly the two women who started it all — Betty O'Neil, now 85, and Kathy DiMaio, 84. Those who thought the original show was hung in the redwoods on the ridge or at Grandpa Charlie's Park on Gualala Ridge, or in Jessie Cranston's garden might want to come to that dinner and hear the story from this year's honorees.

Redwood bark was attached to wooden tables and display stands. Photo courtesy Betty O'Neil.

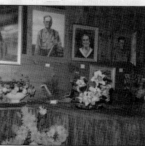

Most of the art was by local artists. Photo courtesy Betty O'Neil.

Bonsai entries were featured in the second show in Gualala. Photo courtesy Betty O'Neil.

The early years

By Frank Healy

The many versions of where the original Art in the Redwoods (AIR) was held stem from the fact that before finding a permanent home at its current location at the Gualala Arts Center numerous venues were used.

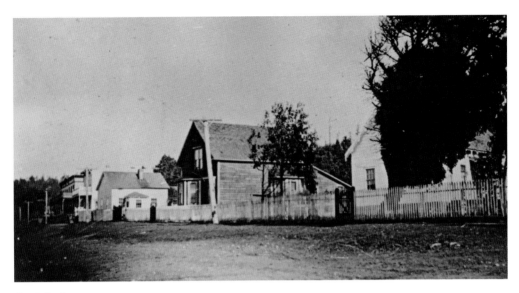

Gualala Arts

It took 18 years to raise the money to build the Gualala Arts Center, with major donations from Peter Mohr, the Irvine Foundation, and Alan and Janet Coleman. In 1990, Gualala Redwoods gave Gualala Arts 11 acres. The 2010 board of directors and officers of Gualala Arts are Michele Marshall, president; Helen Klembeck, first vice president; Martha Wohlken, secretary; Don Krieger, treasurer; and David "Sus" Susalla, executive director. Gualala Arts also operates The Dolphin gift shop. Gualala Arts's mission is to ensure the future of arts in the area. This mission is particularly important in a remote area. The facility is used for classes, presentations, and exhibits. (Courtesy of Kathy Rubel Dimaio and Gualala Arts.)

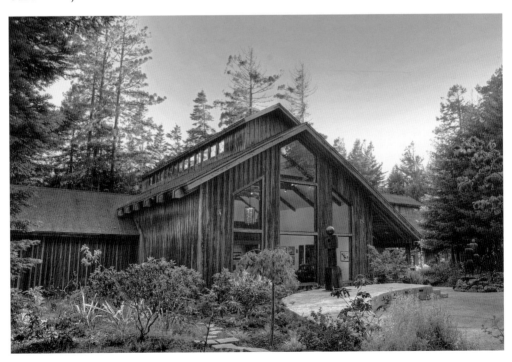

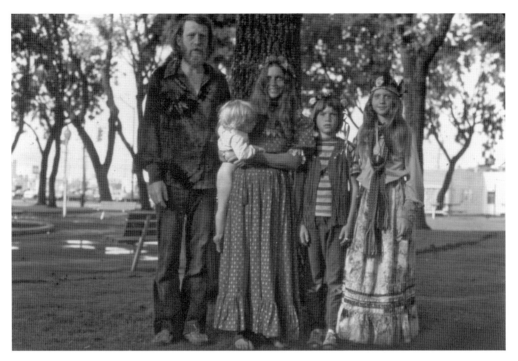

The Kroll Family
Lawrence (Redwood) and Maggie (Savitri) Kroll lived in Davis, where Redwood was a professor at UC Davis. They had a dream of starting a more communal lifestyle for their family of three children. They purchased some land in Mendocino County near Point Arena and invited others to live with them. About six families initially moved onto the land. (Courtesy of Lawrence Kroll.)

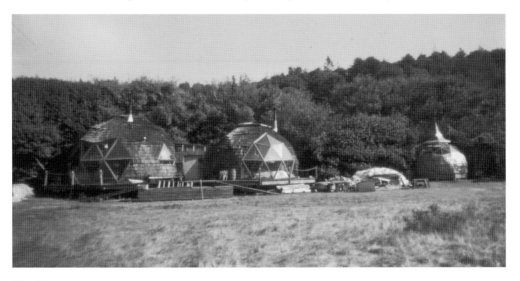

The Domes
The Krolls as well as several other families and individuals named the land "Oz." They built domes for people to live in. Some families had cabins and others had teepees. They had a central barn with a community kitchen and planted a large garden. (Courtesy of Lawrence Kroll.)

The Swinging Bridge
This bridge was a favorite project of Lawrence Kroll. It was built to cross the Garcia River. In the winter, the Garcia would flood some of the land. They lived without electricity. They often invited many inspiring philosophers, artists, teachers, and writers to visit the land, offering classes and discussions. (Courtesy of Lawrence Kroll.)

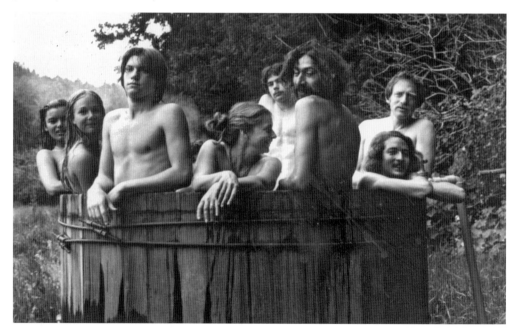

Hot Tub
Helen Nestor documented the Kroll family in her book, *Family Portraits in Changing Times*. Members of Oz were immortalized in this 1978 photograph. In 1984, the Krolls dissolved the commune and moved back to San Francisco. (Courtesy of Lawrence Kroll.)

The Modern Krolls

Pictured are, left to right (front row) Lawrence Kroll and Zoey Kroll; (back row) Cousin Sue, Kevin Volkan, Savitri Kroll, Max Volkan, Panda Kroll Volkan, Jon Kroll, and Karen Kroll. (Courtesy of Lawrence Kroll.)

Alix and Jim Levine

Alix and Jim Levine and their two children moved to the Village (now known as Oz) in 1971 in order to explore new possibilities. Although they moved away from the commune about three years later, they continued to live in the area. They both have continued to give to the community. Jim is director of Mendocino Youth Project, which encourages youth to pursue educational projects, and Alix is chairperson of the Coast Community Library. (Courtesy of Lawrence Kroll.)

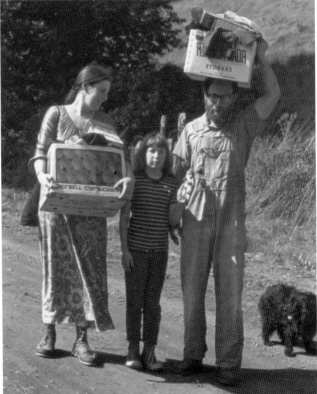

The *Ridge Review*
Jim and Judy Tarbell of Annapolis began a small magazine called the *Ridge Review*. Their magazine, which was published from 1979 to 1985, covered many topics of interest such as employment, natural resources, and the arts, as well as profiling residents. (Author's collection.)

Shirley Zeni
Daughter of Ralph and Sadie McMillen, Zeni had a zest for life. She grew up helping in the family-owned store, McMillen's General Merchandise, which was later named the Point Arena General Store. She married Dale Beltz Sr. and had four children: Dale, Theresa, Ralph, and Ron. After Dale's death, she married George Zeni and assisted with archaeological discovery at the Zeni Ranch. An avid historian, she was also very interested in music and served as pianist for several churches. She also was an avid supporter of the arts, the Point Arena lighthouse, and the South Coast seniors. Many people considered Shirley the unofficial historian of the area. She loved life, her family, and the Sonoma Mendocino coast. Shirley passed away in 2010. (Courtesy of Dorothy and Gary Craig.)

Cheri Carlstedt

Cheri Carlstedt is the unofficial coast historian. She and Steve Oliff not only wrote a book on the history of Point Arena, they created a much broader interest in the town and surroundings. Cheri is the daughter of Norma Scaramella and Sam Iversen (grandson of Soren Iversen). She lives in the Iversen family home that was built in 1870. (Courtesy of Cheri Carlstedt.)

Steve Oliff

Steve is a man of many talents. He is a noted colorist and cartoonist and has worked for Marvel and Lucas Films. He was also Point Arena's mayor and managed the Arena Theater. He regularly gives history talks in reference to the book he wrote with Cheri Carlstedt. (Courtesy of Steve Oliff.)

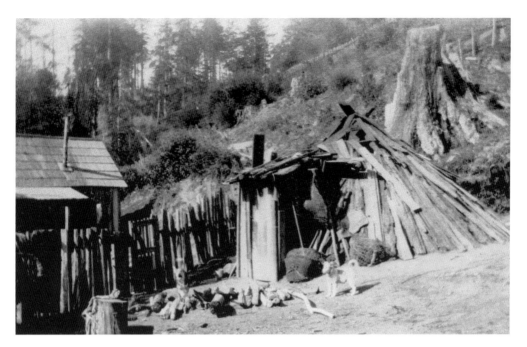

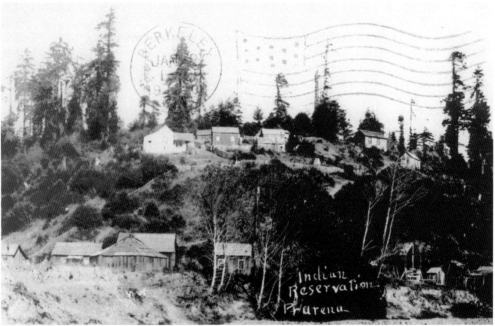

The Point Arena – Manchester Pomo

The Point Arena – Manchester Rancheria – the Reservation – was officially chartered in 1936. Many years before, when the first European settlers arrived, there were few struggles between Native Americans and the newest pioneers. Finally, a section of land between the two towns was officially designated as the reservation. Sidney Parrish was the head of the tribe at that time. (Courtesy of Cheri Carlstedt and Steve Oliff.)

CHAPTER TWO

Legends

Some things and some people are larger than life itself. Say their name and someone smiles. They inspire—these almost unbelievable people or things that epitomize the power of the human spirit. Some Legendary Locals are humanitarians—others are just colorful characters. Some legends are not even people. The *Sea Foam*, until it wrecked, was the legendary schooner that brought people to and from San Francisco in the early part of the century. It was also famous for making its passengers seasick. Malo Pass, as it's called, is the legendary "bad pass" that required early travelers to dismantle their wagons and tie kids together with ropes in order to descend and climb up through it to travel down the coast. The Fourth of July parade is legendary in Point Arena for its Goddess of Liberty and the march of the fools.

Other Legendary Locals are the people who have made the area what it is: an interesting blend of ingenuity and colorful spirit. Billy Ketchum was a legendary bartender and gun collector. Charley Dock was the first Asian American to set up his own shop. The country doctors, Dr. Huntley and Dr. Pitts, delivered all of the babies and tended the ill and deceased. Bernard Parks was a legendary rancher and do-everything kind of guy whom everyone still talks about with a grin. Jay Baker moved to the coast from Arkansas with the ambition of building his own dream—Bakertown—and he did that. Even his burial spot is a legend in that he is buried with his dog next to him behind his store. Legendary loggers abound. This volume only includes a few that could be documented with photographs. Some legends are even still living. Barbara Black, whose grandfather was George Call of the Call Ranch at Fort Ross, still maintains her family's ranch. The epitome of this is Steve Oliff. Steve grew up on the coast, attended local schools, and then became a famous colorist and comic book artist. He also was, at one time, Point Arena's mayor and wrote an acclaimed book on the history of Point Arena with Cheri Carlstedt. Cheri, also a native coast person, is famous to all for being one of the unofficial coast historians of Mendocino County. People from all around drop old photographs and memorabilia on her front porch. She is very knowledgeable about local history and shares that information with anyone who is interested.

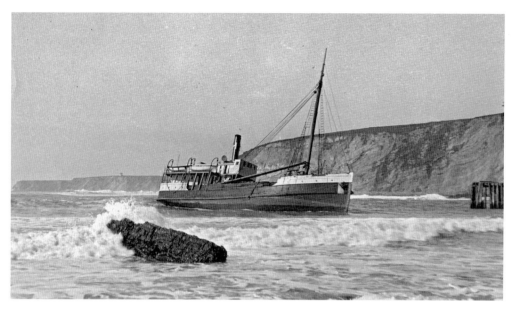

Summer Schedule Of

The STEAMER

SEA FOAM,

CAPTAIN HENDRICKSON.

Summer schedule for the steamer "Sea Foam" between San Francisco and Point Arena, from our North Greenwich Street Dock, No. 1 (Pier 2), for passengers and freight.

Sundays Sailings for Passengers and Perishable Freight.

LEAVING SAN FRANCISCO.

Sundays 6 p. m.		Wednesdays 4 p. m.		
May 17	"	20th	"	"
" 24	"	27	"	"
" 31st	"			
June 7th	"	3rd	"	"
" 14	"	10	"	"
" 21st	"	17	"	"
" 28	"	24	"	"
July 5th	"	1st	"	"
" 12th	"	8th	"	"
" 19	"	15	"	"
" 26	"	22d	"	"
		29		
Aug. 2nd	"	5th	"	"
" 9th	"	12	"	"
" 16	"	19	"	"
" 23rd	"	26	"	"
" 30th	"			
Sept. 6th	"	2nd	"	"
" 13th	"	9th	"	"
" 20	"	16	"	"
" 27	"	23rd	"	"
		30th	"	"

Leave Point Arena for San Francisco every Monday and Saturday at 7 p. m.

Summer excursion tickets from San Francisco to Point Arena and return—good for 30 days—$8.00.

JAS. HIGGINS & Co., Agent,

The *Sea Foam* Schedule (LEFT) The *Sea Foam* was built by Charles Fletcher, Captain Thomas Kennedy, and his brother, James Kennedy of Navarro, for C. Goodall of San Francisco. The coast residents relied on the *Sea Foam*. It had two masts, which helped it gain speed with favorable conditions and, more importantly, steady the ship in fierce winds. The *Sea Foam* carried everything the coast residents needed: equipment for the mills such as saws, clothing, furniture, and even pianos. (Courtesy of Cheri Carlstedt and Steve Oliff.)

The *Sea Foam* (LEFT)

The *Sea Foam* was a steamer built in 1904 of Douglas fir. It was 127 feet long and 32 feet wide. She had a 500-horsepower compound engine and could haul 250,000 board feet of lumber or cargo and passengers. Items hauled to the *Sea Foam* were carried by a wire cable out to the vessel. Lumber from the Mendocino coastline was hauled to San Francisco to build homes. Going north, goods and passengers were hauled to the coast. The *Sea Foam* served the coast until 1931. (Courtesy of Cheri Carlstedt and Steve Oliff.)

The Wreck of the *Sea Foam*

The *Sea Foam* crashed in February 1931 on the south reef of the Point Arena harbor. It was en route from Eureka to San Francisco, stopping in Point Arena to pick up freight. As the captain was entering the harbor, he decided that the water was too rough, but when he was bringing the boat around, the boat was caught by a heavy tow and carried around to the reef, smashing it. The Coast Guard launched a boat with a crew of seven and despite the rough seas and 45 mph winds, were able to rescue all of the 19 men on board. The *Mendocino Beacon* reported, "Eye witnesses to the rescue praise the seamanship of the coast guardsmen and their prompt action in removing the men." (Courtesy of Cheri Carlstedt and Steve Oliff.)

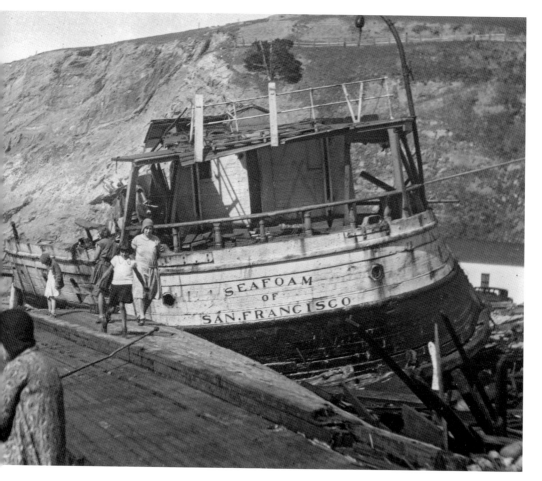

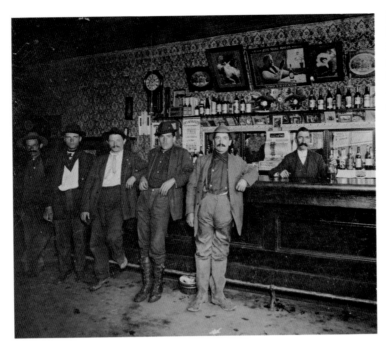

Billy Ketchum
Besides being a bartender, constable, rancher, hotel manager, and gun collector, Billy Ketchum ran the Point Arena Hot Springs. One of the coast's most colorful characters, Billy was orphaned at a young age and died in 1918. (Courtesy of Cheri Carlstedt and Steve Oliff.)

Charley Dock
Charley Dock (Yee Wah) was born in China and came to California for the Gold Rush. He was a cook for a logging outfit for many years and started his own store, the Yee Wah & Co, as a dealer of a little bit of everything, including Chinese herbs, candies, liquor (even when it was illegal), and silk clothing. He was a charming, funny man who warmed hearts. (Courtesy of Cheri Carlstedt and Steve Oliff.)

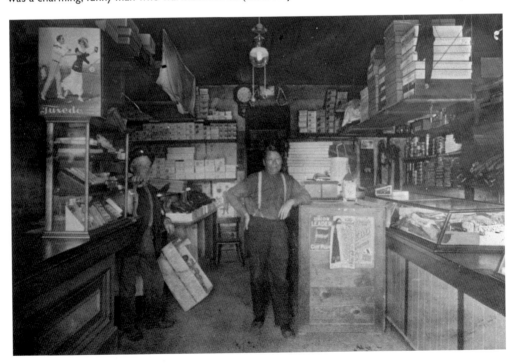

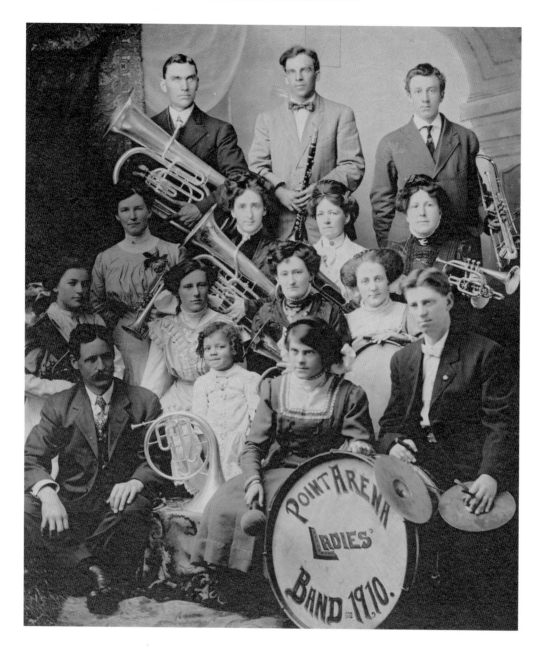

The Point Arena Ladies Band
Community bands were organized for social events. In Point Arena, the 1910 band comprised residents from many of the founding families. Shown are, left to right (top row) Vino Bowles, Tommie Telles, and Thomas W. Halliday; (second row) Lena Jensen, Mrs. Diddle, Lillie Belle Scott (whose family owned Scott's Opera House), and Nettie Dixon; (third row) Lorraine Hughes, Bernice Ainslie, Ella Ainslie, and Edna Antrim; (front row) Mr. Diddle, Pauline Dixon, Helen Zimmerman, and Theodore Jensen. (Courtesy of Cheri Carlstedt and Steve Oliff.)

The Goddess of Liberty
The Fourth of July was a very popular holiday along the coast. The Goddess of Liberty was voted upon by residents. In this photograph, Grace Rankin is shown on her float. Competition for this cherished role was fierce. (Courtesy of the Kelley Museum.)

Big Bert and the Old Milano
At the north end of Gualala, the old Milano Hotel was built by Bert Luchinetti ("Big Bert"). He purchased the land from the Ingram family and built a combination inn and saloon. The townspeople all called the hotel "Big Bert's" after its owner, Bert, who was a hearty fellow. Big Bert owned the hotel until 1922, when it was purchased by Einar H. Andersen, from Norway, who owned it until 1951. In this 1905 photo, Big Bert is in the front row, third from left. On the landing steps are, left to right: Rose Luchinetti, Mary Luchinetti, and Hazel Gianoli (child) in front of them. (Courtesy of Cheri Carlstedt and Steve Oliff.)

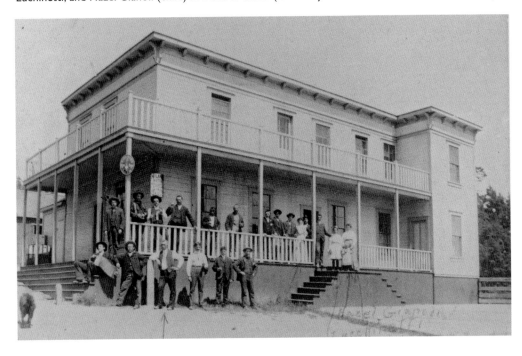

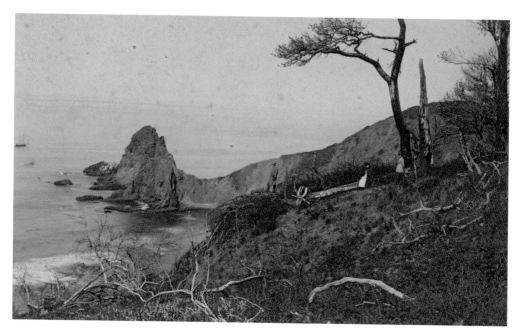

Mallo Pass

Settling on the coast in the 1800s meant travelling by wagon down dangerous passes. Mal Pass or "bad pass," located north of Manchester, was notorious. Even seasoned travelers dreaded this pass as it was 200 feet to the bottom of the gulch. Some families talk of having ancestors who had to take wagons apart piece by piece and lower them with ropes down the deep gulch. Children had to hold onto adults while descending the jagged rocky peaks down to the creek and back up the other side. This c. 1900 photograph shows Ella Fairbanks Walker, seated, with other family members, at the edge of what is now commonly known as Mallo Pass. The Walker family is one of the early pioneer families in the Manchester area. Ella Grace Fairbanks, daughter of Frank Fairbanks and Mary Moss, married Elmer Walker in 1915. Her grandfather, Henry Fairbanks, died in Point Arena in 1873. Ella Walker was the mother of Dorothy Walker Halliday (who is profiled in this book.). (Courtesy of Cheri Carlstedt and Steve Oliff.)

Wes Shoemake
Descendant of one of the founders of Point Arena, Wes Shoemake was a bartender at the Charley Palmer's saloon. This photograph was taken in May of 1914. There were nine saloons in Point Arena in the early 1900s. (Courtesy of Cheri Carlstedt and Steve Oliff.)

The Country Doctors
Dr. Pitts and Dr. Arthur Huntley were the pioneer doctors in the area. Doc Huntley, as he was called, was born in Manchester and trained in San Francisco. He and Dr. Pitts handled all of the medical needs of the community and delivered many of the babies. (Courtesy of Cheri Carlstedt and Steve Oliff.)

Tom Moungovan
Moungovan was born in 1887. His father was a bull driver for the ox teams. In 1960, Moungovan wrote a booklet called "Logging with the Ox Team" in conjunction with the Mendocino County Historical Society. (Courtesy of Mendocino County Historical Society.)

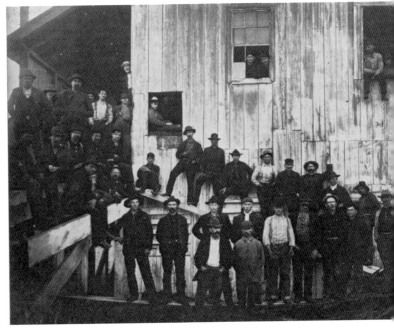

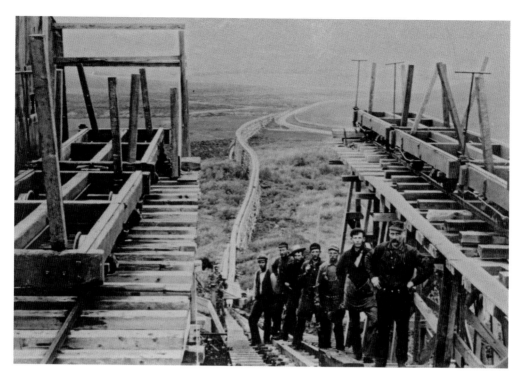

Rollerville Crew

One of the area's first lumber mills was the Garcia Mill, which was located up the Garcia River. Rollerville, sometimes called Flumeville, was located just north of Point Arena. Since the Garcia Mill was several miles from the sea, the lumber was floated on raised water troughs. At Rollerville, a hoisting mechanism pulled the lumber 300 feet to the top of the hill. This 1897 photograph shows the Rollerville hoisting crew. Pictured are (top to bottom) Israil Carlson, machinist; Louis Nissen; Charles Dahl, blacksmith; Victor Nissen; Crosby Cureton; Ben Lyons; and Neil McCallum, oiler. (Courtesy of Cheri Carlstedt and Steve Oliff.)

The Water Wheel

At the end of the Rollerville flume, this legendary water wheel powered the hoist. This water wheel was an incredible labor saving device. Extremely well constructed, it was very large. To better gauge its size, if you look closely at the center of the wheel, you can see a man standing. (Courtesy of Cheri Carlstedt.)

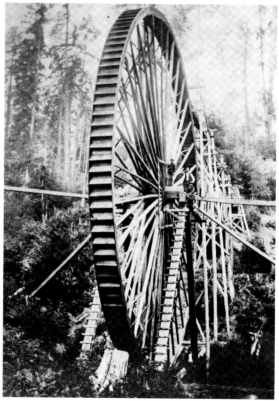

Jay and Reathel Baker
J.D. Baker was born in Shirley, Arkansas, on October 28, 1930. He married Reathel on August 12, 1948, in Merced, California. Their first child, Philip, was born December 27, 1950. They went on to have Jerrold, Michael, Connie, Barbara, and Reathel Joyce. (Courtesy of the Baker family.)

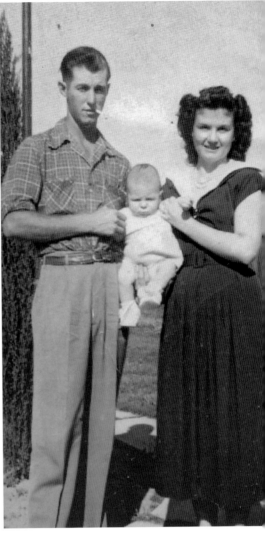

Jay Baker and Bandit
Baker began developing his own logging and hauling business while buying up land in Gualala. He opened his hardware store, then additional businesses in what he named "Bakertown." (Courtesy of the Baker family.)

Bakertown
Jay Baker died in 2000. Jay's children Jerrold, Barbara, and Joyce now run the Baker Hardware store in his legacy. When Jay died, he was buried behind his store with his dog, Bandit. (Courtesy of the Baker family.)

Bernard Wilbur Parks, Senior

Parks was an Annapolis legend. Born in Healdsburg in 1913, he moved with his family to a ranch near Stewarts Point shortly thereafter. As a child, Bernard showed an aptitude for geology and surveying even without access to a high school education. An avid reader who taught himself, he worked for the county, maintaining roads and bridges. Parks led a pioneer life on his ranch without electricity or a phone. He built his own 16 foot boat, collected antiques, was an expert timber hewer and was a good steward of the land. His motto on life regarding mechanical items was to have three of everything: "one that runs, one that could run with a little work, and one for spare parts." Parks had four children: Bernard Junior (whose wife, Annette wrote q *awala-li, Water Coming Down Place- A History of Gualala*;), Calvin, Albert and Alice. Alice and her husband, Ed Garrett continue to live on the family ranch and are very active in the Annapolis Historical Society. Pictured is (left to right) Bernard Parks and Edward Kelly. (Courtesy of Edward Kelly.)

Ernest and Jennie Titus

Ernest Titus was a brakeman for the San Francisco cable cars. In 1895, he travelled up the coast to visit a cousin and met Jennie Gussman, the daughter of Belinda Gussman Hamilton (wife of Stephen Hamilton, son of J.A. Hamilton) from her first marriage. Ernest could not get Jennie out of his mind, and they ended up getting married in 1896. Ernest was involved in many different occupations; he ended up being a major bridge builder on the coast from Gualala to Fort Bragg, had his own construction company, and worked in the lumber industry. He and Jennie had 13 children: Lilburn, Arthur, Julia Mae, Bessie, Wanda, Ernest Edward, Edythe, Cora, Stanley, Laurence, Virginia, Paul, and Wayne. Jennie was a hardworking woman with 13 children to care for. She also taught herself piano. Then, in July 1953, Jennie suffered a stroke and passed away. Ernest passed away 10 years later in 1963. This was the start of the Titus family in Mendocino County. (Courtesy of Jim Bentley and Pat Hansen.)

Lynn Hay Rudy
Author of *The History of the Salt Point Township*, Lynn lives at Stillwater Cove, just north of Fort Ross. A local historian, she volunteers every week at Fort Ross at the Call House. Lynn also volunteers regularly at the Fort Ross Interpretive Center. (Courtesy of Lynn Rudy.)

The Old

SALT POINT TOWNSHIP

Sonoma County, California
1841-1941

Lynn Hay Rudy

Barbara Black
Granddaughter of George Call, Barbara Black is a 94-year-old rancher. Still running sheep into her 90s, Barbara is a legend on the coast. Black also wrote a booklet on dairy farming in the Fort Ross area. She has worked tirelessly for the Fort Ross Interpretive Center since its inception. Pictured are, left to right, Lynn Hay Rudy, Barbara Black. (Courtesy of Fort Ross Interpretive Association.)

Jean Crispin Piper
Piper moved to her family's ranch on Mountain View Road when she was two months old (1916). She attended the one-room Comfort School and Point Arena High School. She married Bob Piper and was the epitome of a rancher's wife. She raised sheep and cattle, hunted deer, drove a jeep, canned fruit, and read the Bible. She also loved to travel, and after her husband died in 1982, she traveled to Europe and Africa. When she died in 2011, she left three children, 13 grandchildren, and one great-grandchild. (Courtesy of Cheri Carlstedt and Steve MacLaughlan.)

John Bower

Bower began purchasing land in Gualala. He built many rental homes for timber workers. He then developed the town's water system. A tenacious debater, he was known to have a firm opinion on matters. (Courtesy of the ICO.)

Ida Gianoli Ciapusci Bower

Ida was born in 1912 to Domencio and Lousia Gianoli. She was the third child. Sedalia was born in 1901 and Albert in 1903. Her brother Frank was born in 1914. The children went to school in a schoolhouse built on the nearby Soldani property. On the ridge, there was usually 100 to 120 inches of rain per year, so the kids only attended school eight and a half months per year. Once a week, Ida rode her horse 12 miles to get the mail. The Gianoli ranch also was a big prune-raising ranch. Albert was well known as a fine accordion player. In 1933, Ida married George Ciapusci, the son of Antonio "Tony" Ciapusci, who ran the Gualala Hotel with his half-brother, Mark Pedotti. George died in 1944. When her husband died, she inherited the Gualala Hotel. She then married John Bower, who died in 1997. Mrs. Bower still lives in Gualala and volunteers in community events. (Courtesy of Kathy Rubel Dimaio.)

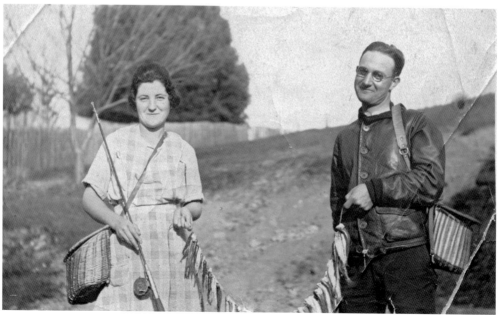

101

Romeo Giacomini

Romeo Giacomini was born in Italy in 1892 and arrived in the United States in 1910. He married Rina Scaramella and was the father of three children: Lester, Gloria, and Clarence. He fought in World War I and passed away in 1955 at the age of 62. His son, Lester Giacomini, was born at Alder Creek in 1920 and was considered a legendary logger. (Courtesy of Cheri Carlstedt.)

Lester Giacomini

Giacomini was born in 1920 at Alder Creek, California. After serving in World War II, he worked in the logging industry from 1949 until he retired in the early 1980s. He married his wife, Millie in 1950 and had three sons: Warren, Lester Junior and Michael. Giacomini earned the reputation as a legendary logger. At Mal Paso Creek, he logged 12 million feet over a two year period. He was also well know for making homemade Italian sausage. Giacomini passed away in July 2009. (Courtesy of Ralph Bean.)

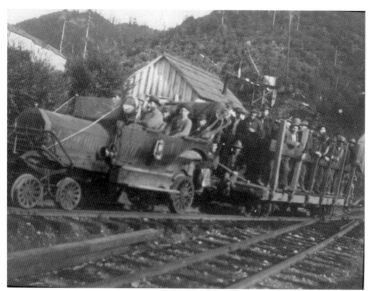

Crew of Camp Eleven
Camp Eleven was a very remote logging camp one ridge east of Highway 1 and west of Cold Springs lookout. In order for the logging crew to get out to the woods, an automobile was converted to be able to ride on the logging train rails. This is the crew going out to the woods. (Courtesy of Ralph Bean.)

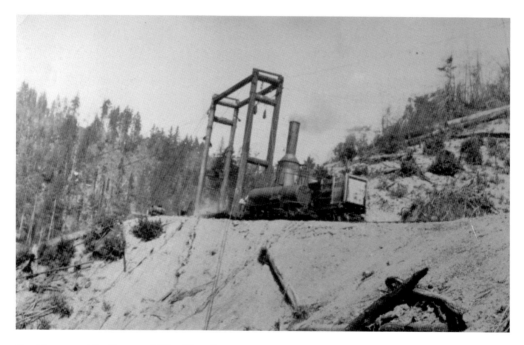

Port Lawson Skyline, or "The Flyer"
In 1903, the woods superintendent of L.E. White Lumber Company in Elk, Sam McCanse, got the idea of stretching a wire between two trees high above the ground and running a carriage along the line, with the donkey, to bring in more logs. It was called "Sam's flying machine." This type of cable system proved to be very useful for spanning the deep gulches that are characteristic of the Mendocino coastline. Based on this idea, Davenport "Port" Lawson, of Manchester, developed the Port Lawson skyline, often called "The Flyer." Port Lawson was the superintendent for Goodyear Redwood Company, the successor to L.E. White. Lawson was born in Boonville, California, in 1872 to Samuel Houston Lawson and Martha Ingram. By 1888, the Lawson family were farming in Manchester. (Courtesy of Ralph Bean.)

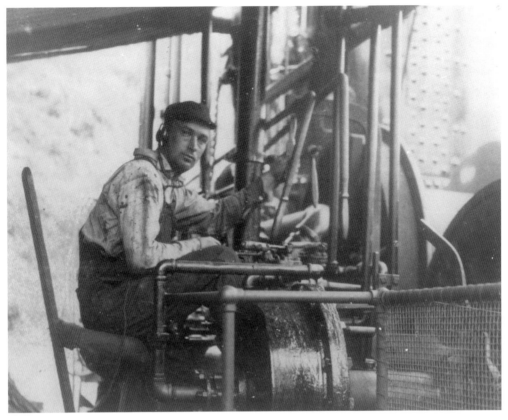

Hugo Dahl

Lawson's flyer was legendary as it spanned three miles, from Adams Ridge to Bald Hill. It was operated by Hugo Dahl. This photo, from the 1920s, is Dahl on the Camp Eleven Alder Creek No. 14 flyer. The flyer was steam operated at 125 pounds. There were 242 tubes in the boiler, and it was operated by oil burners. The flyer came in on the boat *Van Guard*. (Courtesy of Ralph Bean.)

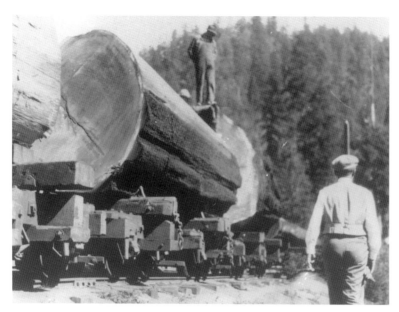

Logs Loaded by the Flyer
The log in this photograph was loaded by Hugo Dahl with the flyer at Alder Creek. Each cut on the log was 16 feet long. (Courtesy of Ralph Bean.)

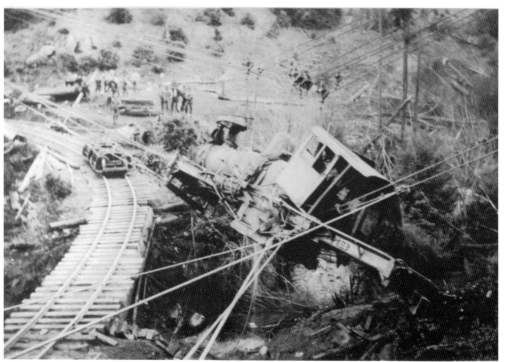

Wreck
According to Ralph Bean, logging using the flyer meant a great deal of precision and some amount of guesswork. Loggers at one end of the line could not see what was being loaded. Then, whatever size loaded on one end, had to be carefully placed on the waiting flat car. Sometimes landings were rougher than expected. In regards to this train wreck, Bean said it was "three days of standing around smoking cigarettes trying to figure out what to do. Then they fixed it on the first try." (Courtesy of Ralph Bean.)

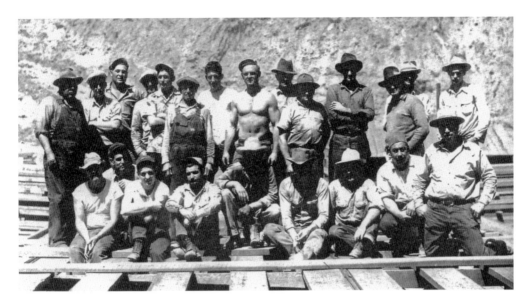

The Crew at Diamantine Brothers Mill

Three Diamantine Brothers, Gilbert, Frank, and James, operated a trucking company in Hayward, California. In 1945, they decided to build their own sawmill in Mendocino County, just east of Manchester on the Piper Ranch. Due to the remote location and difficult access for logging trucks down Mountain View Road, they would have to shut down for part of the year. The mill eventually closed down in 1953 because it could not produce year round. The mill employed a crew mostly from the area. Left to right (front row) Hugh Sullivan, green chain; unknown; Clarence Giacomini, off bearer; unknown; Bill Crispin, green chain; Lester Giacomini, log pond and bucksaw; Danny Pellegrini, grader's helper; Phil Monte, head mechanic and millwright; Joe Francis, right hand man, foreman, and mechanic; (back row) Bucksin, elder man; Bud Hedden, tail edgerman; next four unknown; Ralph Bean, trimsaw operator; Wes Crispin, log pond; Otto Rutter, grader; Shorty Ecklund, sawyer; next two unknown; Stanly (last name unknown); Jimmy (last name unknown). (Courtesy of Roots of Motive Power.)

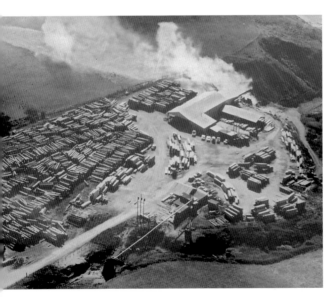

Bojock

In 1946, six Hammond company lumber employees, out of work, decided to form their own lumber company, called Bojock—the name formed by using the first letter of their last names. They were: Everett Bean, Jack O'Conner, Walter Jacobson, Raymond "Chub" Ohleyer, Leroy Case, and Charles Kovacovich. This group constructed a sawmill on Allan Creek that operated from 1947 to 1951. Logging services for the mill were provided by Sam "Spud" Iversen and rough lumber was transported to the Bay Area by Darwin Christiansen. In 1951, they constructed a second mill at Alder Creek, just north of Manchester. In 1954, the mill burned to the ground. (Courtesy of Ralph Bean.)

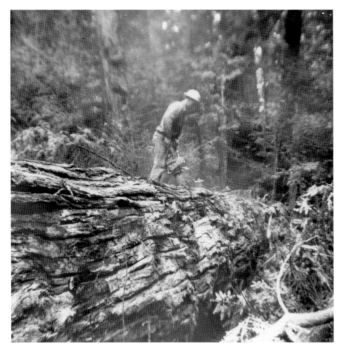

Ralph Bean Logging
Ralph Bean grew up in Humboldt County. This photo, taken around 1951, shows Ralph working with his McCollough 757 chainsaw (7 horsepower and 57 pounds.) At the time, it was the biggest chainsaw made. In 1953, he purchased his own truck and began his own logging and trucking business that was a fixture on the coast for many years. Bean had a half Peterbilt, half Mack truck was unique. (Courtesy of Ralph Bean.)

Ralph and Esther Bean at Their Ranch
After 60 years of marriage, Ralph and Esther Bean continue to live at their family ranch house near Highway One. They met while Esther was in grammar school and Ralph was in high school. Ralph would walk for hours over several ridges to visit Esther while they were courting. (Author's collection.)

NOTES FROM THE

SONG
OF LIFE

A Spiritual Companion
by Tolbert McCarroll

Starcross

The mission of Starcross, a monastic community in Annapolis, is to lead a simple life. The group also has made a special effort to assist children impacted by AIDS. Starcross was formed in 1967 by two Catholic laypeople on a spiritual quest—Tolbert McCarroll, a former lawyer and Marti Aggeler, who worked at the San Francisco's Humanist Institute. The two, now known as Brother Toby and Sister Marti, met at the Humanist Institute and decided to live as celibate monks in an old house in the city. (Author's collection.)

CHAPTER THREE

Personalities

This chapter is about the people and the personalities that make the Sonoma Mendocino coast an interesting place to be. Most people associate the Sonoma Mendocino coast with The Sea Ranch architects and landscape designers, noted writers, artists, and photographers (there are quite a few).

But there are less famous celebrities of the coast that truly make the area fascinating and unforgettable. Florence Silva, of the Point Arena Manchester Rancheria, is a noted elder of the Pomo tribe. Fionna Perkins is known for founding the Coast Library with her husband, Richard. She is also known as a fabulous poet, has published many books, and has served as poet laureate for Point Arena. Jim Hodder, former drummer for the band Steely Dan, was the coast's resident musical celebrity until his death in 1990. However, he was not just famous for his past exploits—he was famous for inspiring young musicians in the area. The St. Orres Inn is like a beacon on the coast highway with its Russian-inspired turrets and stained glass. The famous structure, designed and built by Eric Black, Robert Anderson, and Richey Wasserman, with chef Rosemary Campiformio, revolutionized dining on the coast. Everyone has heard, from one source or another, about the infamous feud between John Hanes and Issac Crispin that resulted in both of their deaths in 1922. One very famous face is that of Sue Gillmore, who has worked in the tiny Point Arena theater booth for the last 43 years. Other noted personalities are Joe Scaramella, who loved history and was a Mendocino County supervisor for over 20 years, and Dorothy Halliday, a committed community-minded volunteer and writer.

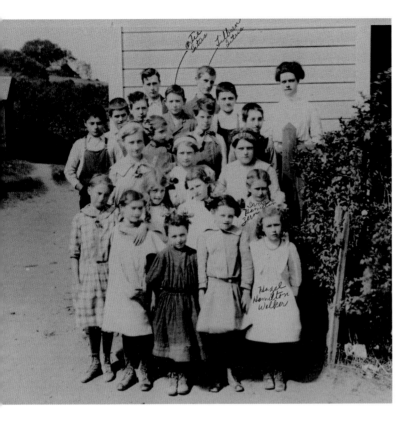

Artie and Lilburn Titus
Artie and Lilburn Titus, sons of Ernest and Jennie Titus, attended the Brush Creek Schoolhouse with other children of the early settlers and ranchers. They grew up to work on many of the bridges in the area, including repairing the Gualala River bridge and the railroad bridges. (Courtesy of Cheri Carlstedt and Steve Oliff.)

Leonard Elvin Craig
Hugh Craig came to California in 1884 from Canada. He settled in Mendocino County around 1900 and married Mary Catherine Dunbar. Hugh worked as a blacksmith at Iversen Landing. Their son, Leonard, was born in 1908 and weighed 13 pounds! In 1928, Leonard began working for the County of Mendocino as a "bridge carpenter." Since bridges were so plentiful in Mendocino county, they needed constant repair. He worked on many of the area's bridges with the Titus brothers. Later, Craig was hired by the City of Point Arena as a city marshal, then a constable. He was the only peace officer from Gualala to Fort Bragg and was in charge of bringing all of the people he arrested to the Justice of the Peace. When he passed away, after working for 40 years as a peace officer, he was the longest serving peace officer in California. Leonard and his wife, Ruby, had three children: Gary, Janet, Dennis and Barbara. (Courtesy of Dorothy and Gary Craig.)

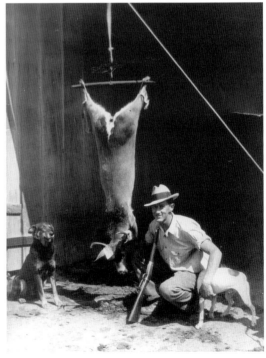

110

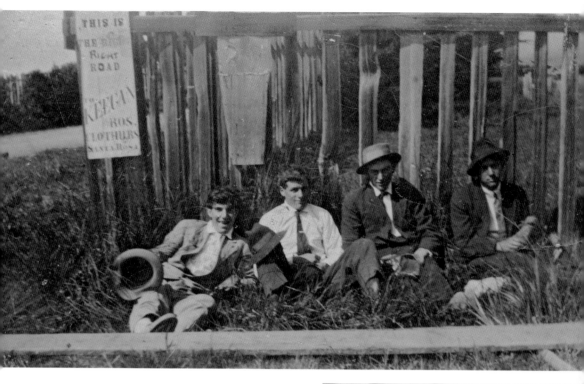

Biaggi Family

Giacomo James Peter Biaggi, his wife, Luigina and their children John Giovanni Robert, James Peter, Emma, Levia and Julius came to the Mendocino county coast from Switzerland in 1894. This was the start of another long line of Biaggis in the area. John Giovanni's son, John is pictured above. Pictured are St. John, John Biaggi, Bus Bishop and Ivan Lawson. This photograph postcard was taken May 11, 1913 and sent to Helen Hunter of Point Arena. (Courtesy of Joyce Pratt.)

Margarette Biaggi

Born in Oklahoma, Margarette Biaggi graduated in 1940 with a degree in Home Economics. She began teaching at Point Arena High School and married Russell Biaggi (son of James Peter and Flora Biaggi.) Mrs. Biaggi became a well-known home economics teacher. She loved her students, the Future Homemakers of America group, and the Spirit Team. She retired in 1976 after teaching at Point Arena High School for over 30 years. Mrs. Biaggi and her husband had two sons. She passed away on August 20, 2011. (Courtesy of the ICO.)

111

Norma Scaramella
An accomplished horsewoman, Norma and her horse, King, could race all the boys in town and beat them every time! (Courtesy of Cheri Carlstedt.)

Kids and Dogs
This photograph shows several old-time residents when they were young—with their dogs. Shown are, left to right Norma Scaramella, Esther Scaramella Bean, Elmer Scaramella, and Raymond Scaramella. (Courtesy of Cheri Carlstedt.)

S & B Market

The S & B Market, in Manchester, is the classic general store. From nails to milk to wine, you can usually find what you need. Everyone in the area has relied on this little store since the 1800s. It is run by Alan and Karen Sjolund, under the guidance of Burney Sjolund, Alan's father. Burney was raised in Elk then came home to the Mendocino coast in 1945. He and his wife, Dorothy Stornetta Sjolund ran the store for many years until their son Alan took over. (Author's collection.)

C.W. "Holly" Holloway

When Holly Holloway's name is mentioned, everyone usually reacts with a smile. For many years, he was one of the Point Arena High School's bus drivers. He was also a mechanic. (Courtesy of Cheri Carlstedt.)

Armature
Armature is a character invented by Steve Oliff. Armature's adventures are featured each week in the newspaper, the *Independent Coast Observer*. (Author's collection.)

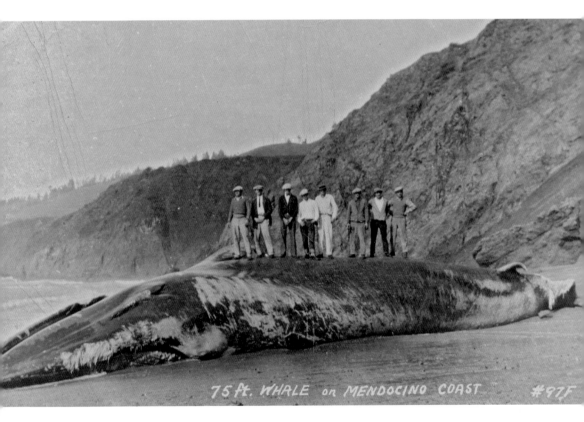

Manchester Whales
Manchester Beach, just north of the Point Arena Lighthouse, is a very long deserted beach, mainly due to the almost constant wind there. There have been many whales washed up there through the years. This photograph, taken around 1900, shows the novelty of being able to stand on a whale. (Courtesy of Cheri Carlstedt and Steve Oliff.)

114

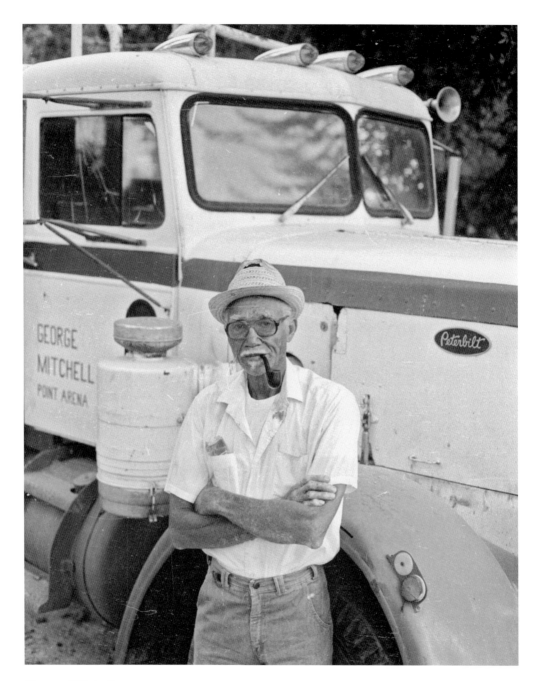

George Mitchell

George Mitchell moved to Point Arena after accidentally stumbling across the town while driving home to Oakland. He fell in love with the area and decided to start a logging business. At first, he commuted, and then moved his family into the area. He was the first African American logger on the Sonoma Mendocino coast. Mitchell was very well respected and considered a hard working man. He ran a full operation and had his own trucks. According to his daughter, Diana Mitchell-Tribble, he logged until he couldn't log anymore. Sadly, in 1991, he died of lung cancer. (Courtesy of Steve MacLaughlan.)

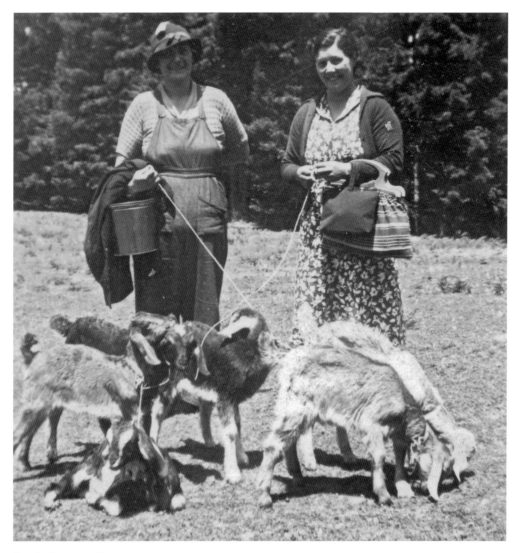

Annie Scaramella

The Scaramella family has several branches. Often one branch of a family from an area in Europe would come to the United States, word would follow, and other family members would emigrate. Annie was born in Italy, and married Carlo Scaramella. He came to the United States, then she followed with their two sons: Joseph and John (ages seven and eight.) They arrived in San Francisco the day before the 1906 earthquake. The earthquake occurred at four a.m. and their hotel caught on fire. They lost all of their belongings and the two boys caught the measles. They did not arrive in Point Arena until several weeks after the earthquake. According to an interview with Joseph Scaramella (by his nephew Mark Scaramella) before he died, his family were nomads, like many poor Italian immigrants on the coast. Joe's dad was a tie contractor so he travelled to various locations for jobs. Two more sons were born: Charley in 1907 and Eugene in 1908. Joe quit school at age 15, left home, married, then returned to Point Arena and opened an auto repair garage and gas station. In the 1930s, he entered politics and served as Fifth District Supervisor for 18 years. In 1980, he was elected to be the mayor of Point Arena at the age of 80. Eugene went on to get a degree from UC Davis in dairy studies. Shown here, from left to right, are Eva Hunter and Annie Bacci Scaramella. (Courtesy of William Kramer.)

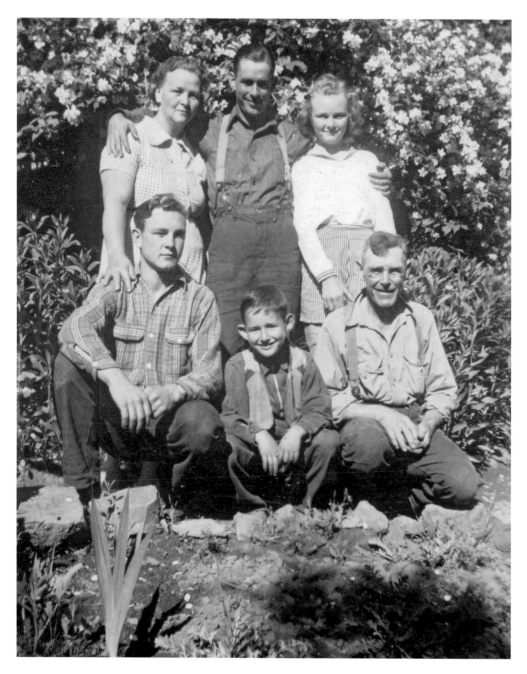

The Crispin Family
Issac "Ike" Crispin moved to Mendocino County around 1870 as a young man. He was involved in ranching on Mountain View Road near Manchester. For a while, Ike ran a post office at this ranch called "Comfort." In 1903, John Hanes and his family moved to a homestead on Mountain View Road. Bad feelings developed between Hanes and Crispin. In 1922, both men were killed in a dispute on the Crispin ranch. Shown here, from left to right, are: (top row) Delva McMillen, George McMillen, and unknown; (front row) Wesley Crispin, William Kramer, and Henry Crispin. (Courtesy of William Kramer.)

Dorothy Halliday
Born in 1919 to Elmer Walker and Ella Fairbanks Walker, Halliday was a 26-year employee of the US Post Office, a milk tester, an active Grange member, historian, lighthouse preservation volunteer, and author of the book Coasting on Home. She loved the coast and had dedicated her life to preserving any or all parts of the local history. She was instrumental in the formation of the Point Arena Lighthouse Keepers Association and was also active in applying for historical status for the area's buildings. (Courtesy of Cheri Carlstedt.)

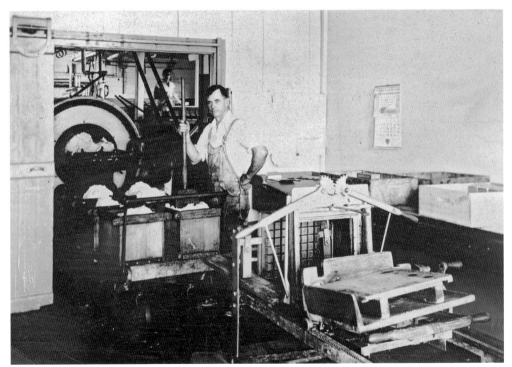

Elmer Walker
Elmer Walker was the foreman of the Manchester Creamery in the 1930s. Born in 1889 on the Charlie Bishop ranch (the Bishops were early settlers in Manchester), Walker was a rancher, farmer, and dairyman. He was the son of William Walker and Minnie McFarland. Walker was known for putting in the first irrigation system on the coast and the first to pasteurize cream. The Manchester Creamery set records at the turn of the century for the amount of butter it produced. Walker died in 1980. (Courtesy of Cheri Carlstedt and Steve Oliff.)

Dorothy and Joe Halliday
Dorothy married Joe Halliday. Both of these two individuals were devoted to preserving the coast's history. They were also very committed to education and donated substantial funds for scholarships. (Courtesy of Cheri Carlstedt.)

Bill and Cathi Matthews
Pictured is Bill Mathews in a photograph by his wife, Cathi. The Matthews spend their lives giving. They moved to Gualala in 1971 and Bill taught at Horicon School in Annapolis. While teaching at Horicon, he changed many lives and opened up new worlds for the students. Cathi worked for the ICO as a reporter and photographer. Now retired, they both volunteer at Pay-n-Take regularly. Cathi is in charge of the book room and Bill is the chief hauler. (Courtesy of Cathi Matthews.)

Point Arena Poet Laureate
Fionna Perkins and her husband founded the Mendocino Community Foundation, were instrumental in Gualala Arts and the Coast Library, and gave back to the community in many ways. Fionna is also an established poet and has written several books. She was named Point Arena's poet laureate. (Author's collection.)

Jimmy Hodder

Hodder was the original drummer for the band Steely Dan. He was born in Boston in 1947. After Hodder joined Steely Dan in 1969, the group made several gold and platinum albums, including *Can't Buy A Thrill*, named by *Rolling Stone* magazine in 1989 as one of the top 100 rock albums of all time. He moved to Point Arena and in 1990 he drowned in his pool. (Author's collection.)

Gillmore

For over 40 years, Gillmore has greeted customers and sold tickets from her booth in front of the Arena Theater. Residents look forward to seeing her cheerful face. Married to Jack Gillmore, she and her husband managed the Gillmore store for many years. (Author's collection.)

Florence Silva

A tribal elder at the Point Arena Manchester Rancheria, Silva has tasked herself with keeping Pomo traditions alive. Seen here in 1972, she is showing Jon Kroll and Josie Martinelli how the Pomo use items gathered from the sea. Silva graciously shares her Pomo knowledge with others. (Courtesy of Lawrence Kroll.)

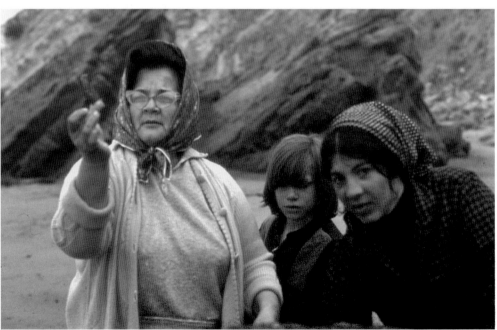

Lori Laiwa

Only 250 Native American women in the United States have a PhD. Laiwa will soon be one of them. From the Point Arena Manchester reservation, Laiwa will graduate from UC Davis with a degree in Native American studies. She specializes in the preservation of the Pomo language. (Courtesy of Lori Laiwa.)

St. Orres Inn

St. Orres Inn is an icon on the coast. The inn is topped with onion-shaped domes and its wooden-shingle buildings pay homage to the Russian fur traders who came to the area in 1812 and established a settlement at Fort Ross. The inn was built by Eric Black, Robert Anderson, Richey Wasserman, and chef Rosemary Campiformio, who—as a framed certificate in the bar notes—forages locally for mushrooms for her guests. The inn was "green" before green was a building concept. The main hotel building was constructed from materials from the original Seaside Hotel. The St. Orres partners bought the property in 1971 and built all of the buildings using salvaged redwood and Douglas fir. The creek's slightly altered name came from the George St. Ores family, who emigrated from Nova Scotia and settled the area in the 1870s. (Author's collection.)

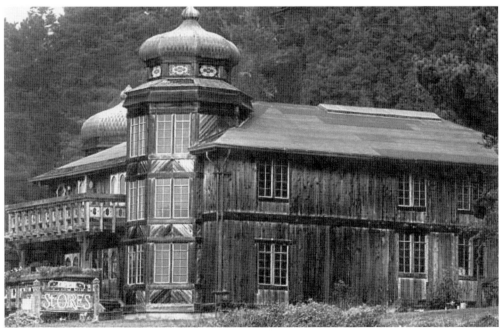

Arline Kramer Day – "Nana"

Born in Point Arena in 1917 to Lovel Hamilton and Eva Helen Hunter, Kramer Day moved from logging camp to logging camp as a young child. She attended Point Arena schools. She was a registered nurse, a devoted mother, aunt and grandmother, loved the coast and her family's ranch that had been in the family since the 1870's. She adored animals, sourdough pancakes, reading a good western and was an inspiration to all. She passed away in 2012 a month before her 95th birthday. (Author's collection.)

Faces of the Coast
Here are a few faces of the coast. Pictured are Thelma Hitchcock, left, and Arline Hamilton, right. (Author's collection.)

Mendocino County Remembered (BELOW)
Bruce Levene, William Bradd, Lana Krasner, Gloria Petrykowski, and Rosalie Zucker (as part of the Mendocino County American Bicentennial History Project and the Mendocino County Historical Society) published two volumes in 2005 of interviews with older Mendocino County residents. These books document the lives and memories of many residents and families, thus preserving stories that otherwise would have been lost. (Author's collection.)

MENDOCINO COUNTY REMEMBERED
An Oral History

Volume II
(M - Z)

A COMMEMORATION OF THE AMERICAN BICENTENNIAL

by
BRUCE LEVENE
and
William Bradd, Lana Krasner, Gloria Petrykowski, Rosalie Zucker

INDEX

AN IMPRINT OF ARCADIA PUBLISHING

Find more books like this at
www.legendarylocals.com

Discover more local and regional history books at
www.arcadiapublishing.com

Consistent with our mission to preserve history on a local level, this book was printed in South Carolina on American-made paper and manufactured entirely in the United States. Products carrying the accredited Forest Stewardship Council (FSC) label are printed on 100 percent FSC-certified paper.

MADE IN THE USA

AN IMPRINT OF ARCADIA PUBLISHING

Find more books like this at
www.legendarylocals.com

Discover more local and regional history books at
www.arcadiapublishing.com

Consistent with our mission to preserve history on a local level, this book was printed in South Carolina on American-made paper and manufactured entirely in the United States. Products carrying the accredited Forest Stewardship Council (FSC) label are printed on 100 percent FSC-certified paper.

MADE IN THE USA